PAST PRESENT

AUBURN

OPPOSITE: This 1970s photograph is of North Lewis Street at Franklin Street. Today, the section of the road in front of the building is gone, as is the Texaco gas station toward the back of the picture. This made way for today's arterial, splitting up Lewis Street. In the 1930s, Market Basket Food Market, owned by H.E. Hovey and associates, operated in the brick building. They had several markets in Central New York. (Courtesy of Cayuga Museum of History and Art.)

PAST & PRESENT

AUBURN

Joseph E. DiVietro

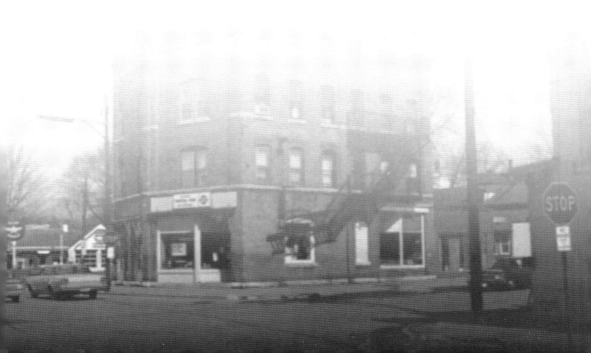

Copyright © 2024 by Joseph E. DiVietro
ISBN 978-1-4671-6114-5

Library of Congress Control Number: 2023947586

Published by Arcadia Publishing
Charleston, South Carolina

Printed in the United States of America

For all general information, please contact Arcadia Publishing:
Telephone 843-853-2070
Fax 843-853-0044
E-mail sales@arcadiapublishing.com

Visit us on the Internet at www.arcadiapublishing.com

On the Front Cover: In 1954, Schooley Contractors got the contract to knock down the old Cayuga County Savings Bank on the corner of Genesee Street at State Street. The building was erected between 1890 and 1891. Nugents Ladies Specialty Shop just to the right of the bank opened in 1942. It was the former Reeds Store. Lane's Millinery is just to the left of Nugents. In 1935, Lane's advertised ladies hats in "youthful large head sizes" for $1.25. The advertisement read, "Smart new styles, the loveliest straws and fabric, in all the popular colors, with value that will thrill you." (Past image, courtesy of Cayuga Museum of History and Art; present image, author's collection.)

On the Back Cover: The foot of Owasco Lake is pictured looking up the Owasco River, or outlet, toward the lake. The pumping station can be seen toward the lake. Notice how everyone is dressed. The outlet is still used today. It flows from the lake, through the city, and into the Seneca River. The outlet is in Emerson Park. Emerson Park and Owasco Lake are major tourist destinations for boaters, fishermen, and families. (Courtesy of Cayuga Museum of History and Art.)

Contents

Acknowledgments　vii
Introduction　ix
1.　The 19th Century　11
2.　Evolving to Present Day　29
3.　Urban Renewal　71

Acknowledgments

I would like to acknowledge and thank the tireless work of the staff at the Cayuga Museum of History and Art in Auburn. Kirsten Gosch, the museum's executive director, along with her staff, Karyn Radcliffe, Geoff Stark, and Haley Boothe, have guided the museum to become one of Central New York's premiere destinations for history buffs and researchers. Without their contribution and support, this book would not have been written.

The work of the Cayuga Museum board of trustees should be recognized. Board president Christina Calarco, vice president Michael Nunno, secretary Rhonda Miller, treasurer Barb Sroka Cushing, Brittany Antonacci, Ally Colvin, Tessa Crawford, Victoria Fitzgerald, Jack Hardy, Thomas Hughes, Helen Littman, and Craig Mietz. I would also like to mention longtime collection committee members Tony Gero and Joe LoPiccolo. Everyone is committed to our local history and place in Cayuga County and beyond.

One hundred percent of the profits from this book will go to the museum.

The Cayuga Museum of History and Art was founded in 1936. Today, the Cayuga Museum presents changing exhibits and public programs and serves researchers on three floors in the historic Willard-Case Mansion. With the direction of the past and current leadership, the museum is well-suited to continue to serve our community for many years to come.

I would also like to thank Andrew T. Simkin, Mark Lawn, Jerry VeVone of Winton Antiques, Peter A. Signor of Smith Old County Store Museum, Lyn DiVietro, and Karen Avery DiVietro for their contributions to this book.

Unless otherwise noted, all past images appear courtesy of the Cayuga Museum of History and Art in Auburn.

Present-day images appear courtesy of the author.

Introduction

Every city has a story written by its citizens and told by its ever-changing landscapes. Auburn is a city known for its famous historical inventors, entrepreneurs, political figures, and its prison, but it is so much more than that. This city, like all of America, has seen its changes over the years. Civil war, world wars, depression, urban renewal, and most of all, progress have taken what generations of citizens have begun and are building on it even today. It went from a place with an agriculture focus to industry to a current shift toward tourism with current points of interest such as the Seward House, Harriet Tubman's home, Willard Chapel, Case Mansion, and Owasco Lake in the heart of the Finger Lakes. Clothing has changed over the years, and vehicles have made drastic changes, going from horse and buggy to electric cars. Businesses have come and gone as well as some streets like Jane Street, Crocket Street, Cumpston Street, and Academy Street. Auburn's story has weathered the test of time and deserves to be told and spoken of for generations to come. This book remembers and honors Auburn's past as we look to its bright and prosperous future.

The city of Auburn was formed in 1793 and became the county seat of Cayuga County in 1805. Originally named Hardenberghs Corners, it was a military tract given to Col. Johannes Hardenbergh as payment for his service to our county. Auburn became a city in 1848. Cyrus Dennis was the first mayor; Mayor Jimmy Giannettino is the current and 56th mayor, and Mayor Giannettino was first elected in 2023. In 1864, Auburn had 50 grocery and provisions stores, 3 coal dealers, 9 carriage manufacturers, 9 butchers, 7 watchmakers, and 4 liveries. John Wall manufactured boots and shoes at 53 Genesee Street, and H.M. Drake was a baker and confectioner at 49 North Street. Charles Coventry manufactured tobacco and cigars at 12 Genesee Street, and George W. Brown was a watchmaker at 51 Genesee Street. The Western Exchange Hotel on Genesee Street at Exchange Street was built in Auburn's infancy stages. Jonas White Jr. was the proprietor and was known for having ample stable accommodations. While these businesses are gone, in the pages coming up you will see many family businesses that are still in operation today.

My connections to Auburn are personal, having been born and raised here. My ancestors chose to settle here, raise a family, and carve out a better life for their children than they themselves had. I honor the sacrifice of my ancestors and all of those in Auburn's past who have made this great city what it is today. This book was born from an idea to honor our ancestors and remember a time when life was much different from our own but vastly important in making Auburn what it is today. Some of the pictures in this book came from my collection, but to share more of Auburn's story, I sought out the help of the Cayuga Museum of History and Art. It holds a vast array of photographs and memorabilia documenting Auburn's past. Its collection, along with other pictures from public citizens, make up this book. I have made every attempt to recreate the exact photographs taken in the past, however, some locations have changed significantly, making this task extremely difficult.

CHAPTER 1

THE 19TH CENTURY

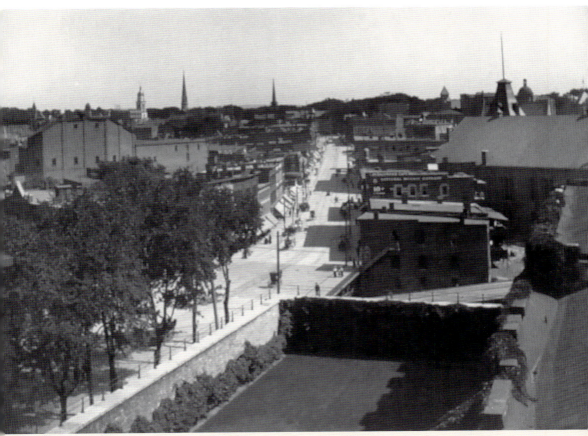

In the 1800s, this image was taken from the top of the Auburn State Prison looking down State Street, toward downtown. The state armory is the large building on the right, and Curley's Restaurant is just across the street. Most of the buildings pictured are gone, they got replaced in the 1970s, and they made way for today's arterial.

This 1800s photograph of the corner of Genesee Street at Exchange Street shows the Fowler and Brother Drug store along with the S. Power Press Book and Card Company. The book company was first listed in the city directory in 1857. Today, Mesa Grande is in its place. Mesa Grande opened in 2010.

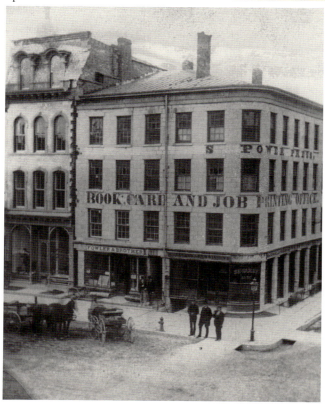

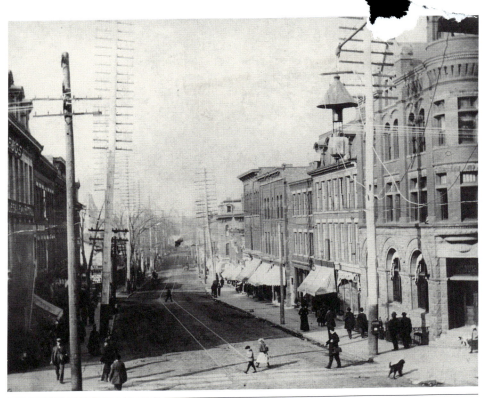

The above photograph was taken on Genesee Street looking down State Street. The Cayuga Savings Bank building is visible on the right side. Trolley tracks stretch down State Street. Today, A.T. Walleys is on the left followed by a city park. On the right side, the buildings that house Prison City, Osteria, and Nash's Art Store can be seen. This area has seen many different buildings and transformations over the years.

THE 19TH CENTURY

13

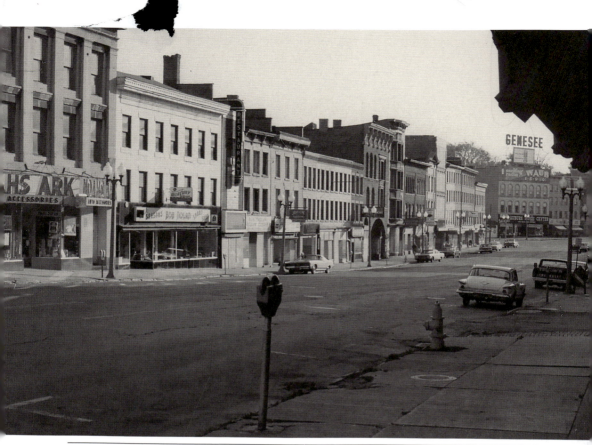

This 1970s photograph was taken on Genesee Street looking east. Noahs Ark auto accessories is on the far left. Bob Nolan Sport Shop is to the right, followed by a restaurant. Electroiux Vacuum Cleaners, the Junior Shop Youth Fashion Center, and W.D. Garney Hardware can also be seen in the photograph. Just three of the structures remain, but the new owner is restoring the buildings with new storefronts and modern apartments on the upper floors.

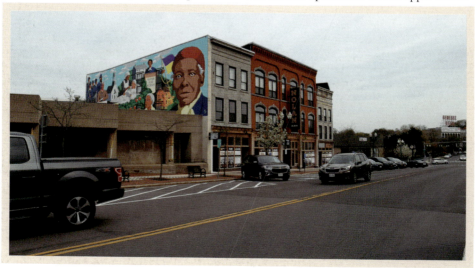

14

THE 19TH CENTURY

This 1865 black-and-white photograph of one of the victory arches was erected on Genesee Street to welcome soldiers of the Civil War back to Auburn. An ivy-covered arch spans the road and has lanterns hanging from the sides. The sign across the top reads, "Welcome Victorious Conquerors." Today, the Liberty Store occupies the same building next to Speno Music. Israel Goldman opened the Liberty Store in 1917, and it is still family-owned. Speno Music opened in 1948 and is still run by the Speno family.

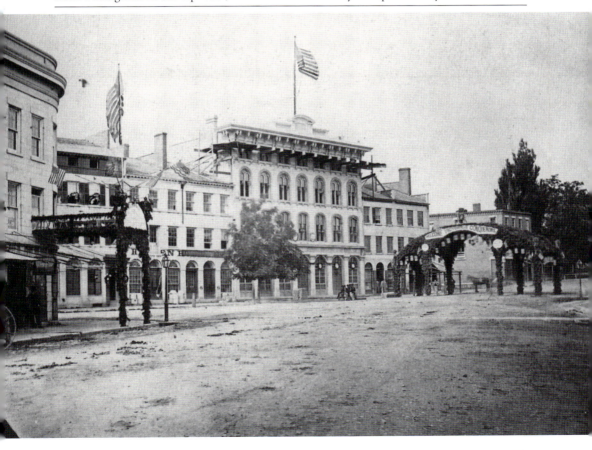

The 19th Century

The Lewis House hotel at 35 Chapel Street can be seen in the photograph below, dated around 1900. The hotel was in operation as the Lewis House from 1897 to 1903. After 1903, the property was owned by the New York Central & Hudson River Railroad. In 1905, the rail company knocked the building down.

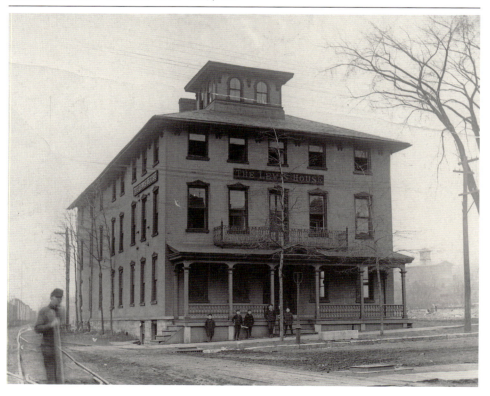

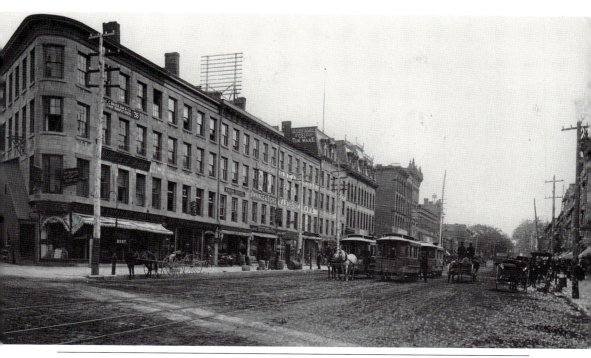

This 1888 view is looking west up Genesee Street from the South Street intersection. The dirt road has trolley tracks. Signs for businesses are visible on the corner building on the left side of the street. They include, from left to right, Dr. Hudson, Operative & Prosthetic Dentist; Geo. Ward Burt, Druggist; William S. Sutton; C. Baker, Son & Co. Cigar Manufacturers; Fitch Insurance; Arbor Hotel; Parker & Gillespie; Grand Union Tea Co.; H.I. Rublee & Son; and Lanehart & Garrett, Loyal Sock & Pittston Coal. Genesee Center is now located on this site. Originally Genesee Mall, it was built in 1971.

The 19th Century

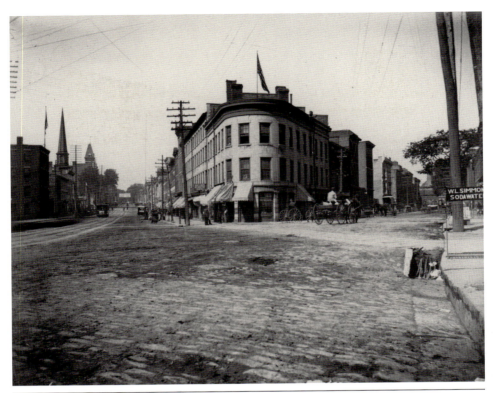

This late-1800s photograph looks at the Flat Iron building on the corner of Genesee and Market Streets. The dirt road with trolley tracks is visible on the left. Trolley cars and horse-drawn wagons can be seen to the left and right of the Flat Iron building. A sign for W.L. Simmon Soda Water is visible on the sidewalk to the right. Today, all these buildings are gone, replaced with a city park.

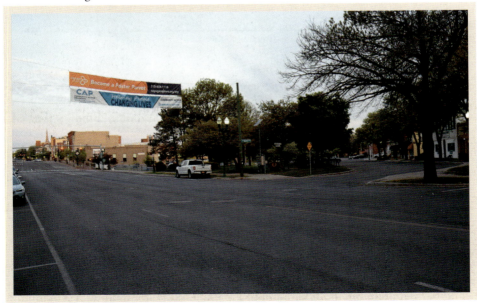

Between 1850 and 1858, this view facing east along Genesee Street was taken from the area of the North Street intersection. Buildings line both sides of the dirt road; horse-drawn carriages are on each side of the road. The area around the church would be the location of Wegmans Grocery Store. Wegmans opened in the spring of 1978.

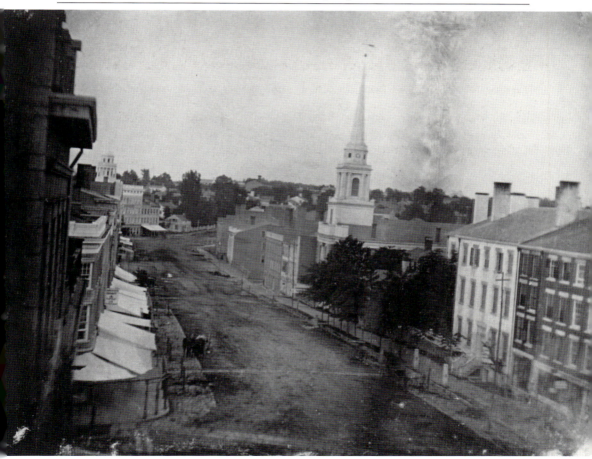

The 19th Century

19

The Cayuga County Savings Bank on the corner of Genesee and State Streets is visible on the left behind a trolley car in this 1899 photograph. Horse-drawn carriages are on the side of the street to the left of the trolley. An advertising sign for Munyon's Homeopathic Remedies and one for the Western Union Telegraph Office is on the right.

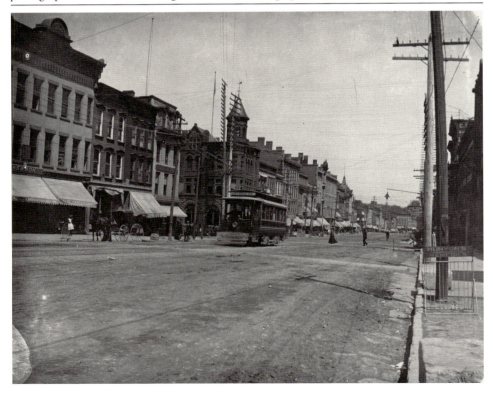

THE 19TH CENTURY

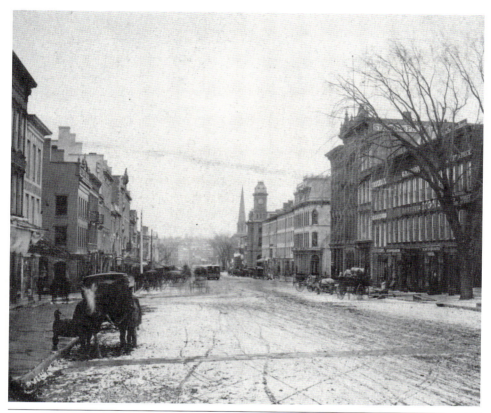

Between 1871 and 1883, this photograph was taken on Genesee Street just west of State Street, looking east. Horse-drawn carriages and wagons line the street with trolley cars visible in the distance. Signs for a dentist, the *Weekly Journal*, and a tea store can be seen on the right. Notice the original clock tower on the Phoenix Building.

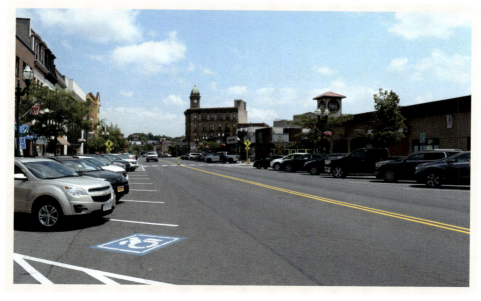

THE 19TH CENTURY

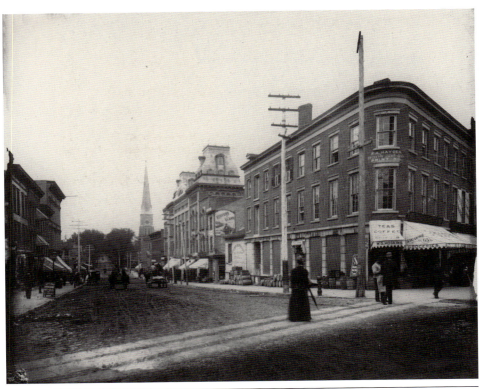

This 1888 view is looking down North Street from the corner of Genesee Street. Looking across the dirt road toward the three-story brick building, on the corner is F.A. Hayden Books and Job Printing and W.G. Hoskins Grocery along with G.N. Oysters and Clams, offered "All The Year Around." Barrels line the sides of the buildings with pedestrians crossing the dirt road. This intersection has seen many transformations throughout the years with many buildings constructed then knocked down on the same block.

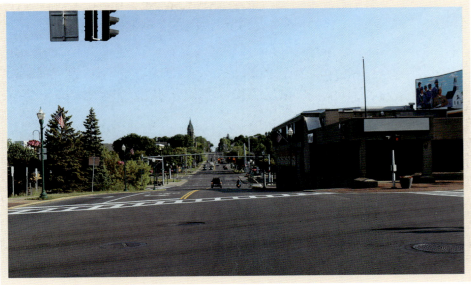

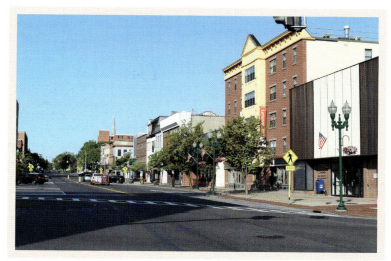

This 1890 print of Genesee Street looking west shows a row of buildings lining the right side of the street. Horse-drawn carriages stopped along the sidewalk with a trolley running down the street. Pedestrians walk on the sidewalk in front of the shops. S. Rosenbloom & Sons boots and shoes can be seen on the bottom right at the corner of Genesee and North Streets. The company moved to this location on Genesee Street in 1888. Today, Lattimore Hall, a furniture rental store, and Silbert Optical can be seen.

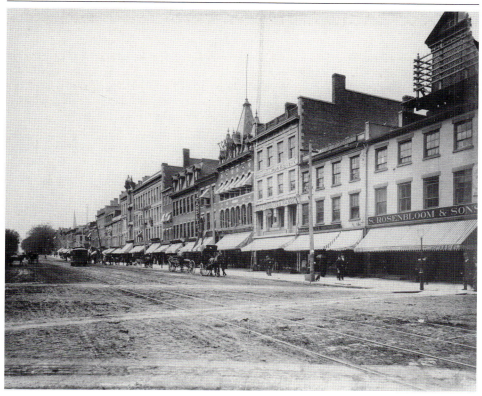

THE 19TH CENTURY

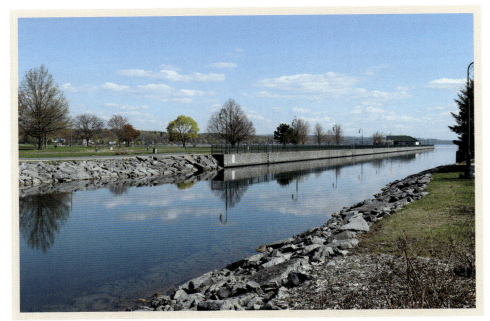

The foot of Owasco Lake looking up the outlet toward the lake can be seen in the photograph below. The pumping station can be seen toward the top. Notice how well everyone is dressed. A steam-engine boat is heading toward the lake. Today, the outlet is still in use as a gateway to Owasco Lake.

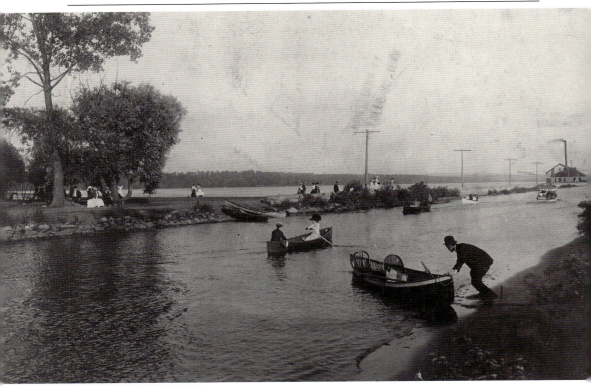

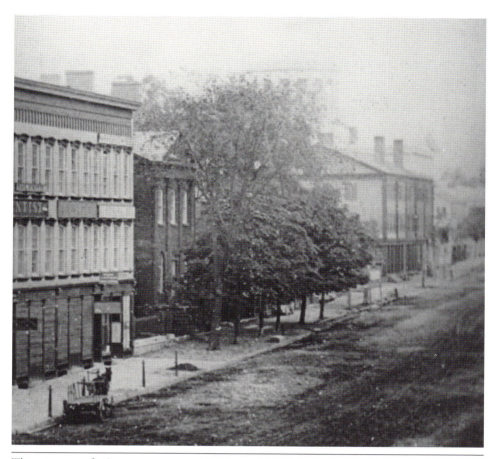

This image of Genesee Street with the courthouse dome visible in the background was taken in the late 1800s. The buildings line the dirt street. Horse-drawn wagons are on the side of the street on the bottom left. Today, the Metcalf Plaza occupies the property. The courthouse remains in the same location. The Metcalf Plaza was built in 1968.

THE 19TH CENTURY

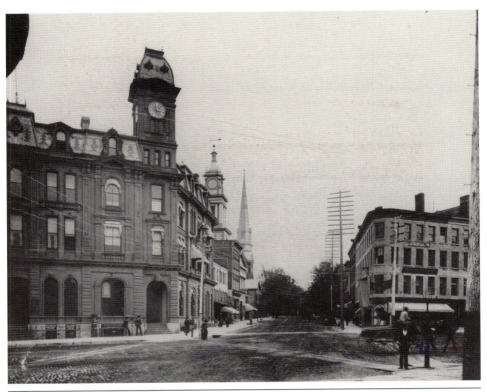

This image of the Auburn Savings Bank on the corner of Genesee and South Streets was taken in 1888. C. Baker, Son & Co. Cigar Manufacturers can be seen in the upper right. The Genesee Center building is now on the right. The bank building remains but with a new clock tower.

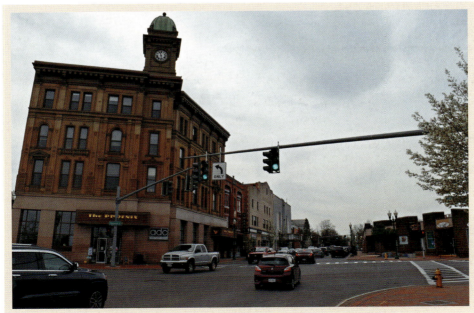

This 1800s photograph shows the corner of Genesee and North Streets. The view is looking across the dirt road toward a three-story brick building on the corner housing F.A. Hayden Books and Job Printing and W.G. Hoskins Grocery. Pedestrians can be seen crossing the street, with horse-drawn wagons driving on the road. Today, just three of the buildings are left standing.

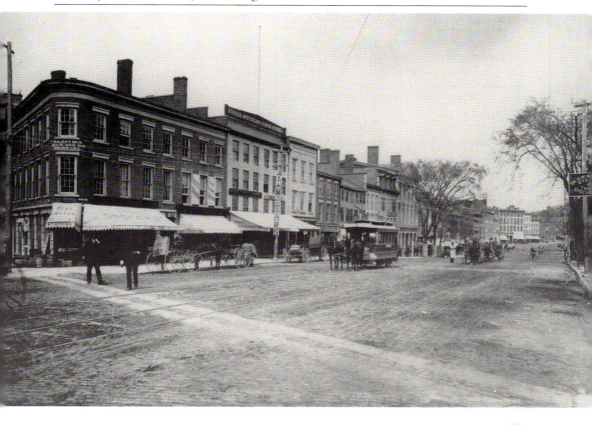

THE 19TH CENTURY

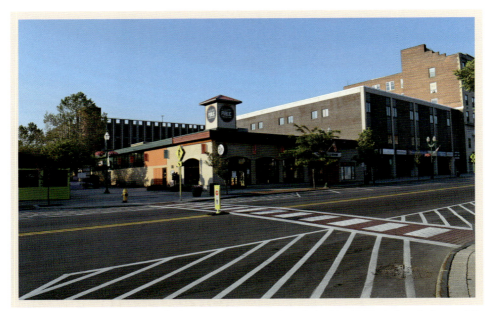

This 1840 photograph is of the Western Exchange Hotel on the corner of Genesee and Exchange Streets. The hotel was built by William Bostwick between 1803 and 1804. It was demolished in 1868. Auburn's first public ball was held here. Today, Café 108 and the Auburn Public Theater occupy the space.

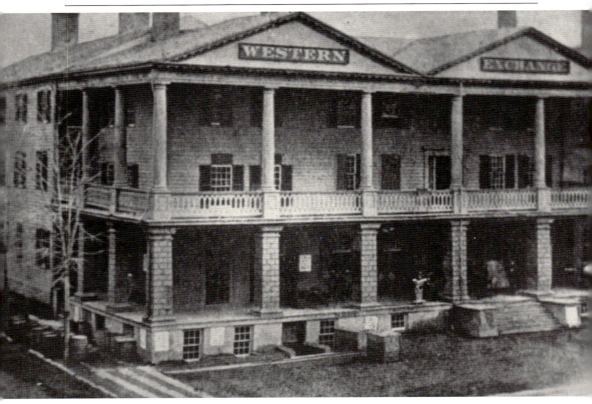

CHAPTER 2

Evolving to Present Day

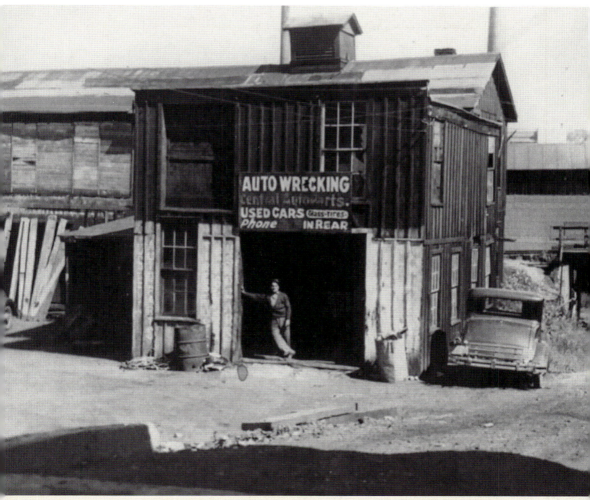

Michael DiVietro, pictured, operated Central Auto Parts on the old Route 5 and Route 20 West near Clark Street, today's arterial.

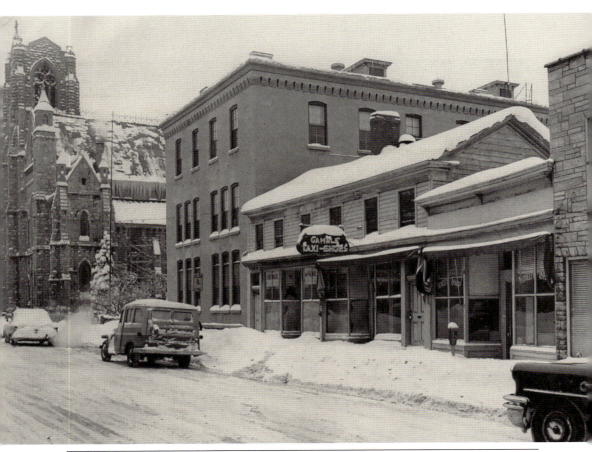

St. Mary's Church on Clark Street can be seen in the background. The photograph, taken near Dill Street on Clark Street, is looking west in the 1970s. The first storefront is the Novelty Shop with Gamble Taxi and Shoes next door at 7 Clark Street. In 1946, Gamble shoes offered free waterproofing with the purchase of work boots. Today, Clark Street is a one-way street. St. Mary's Church rectory is now just to the right of the church.

Evolving to Present Day

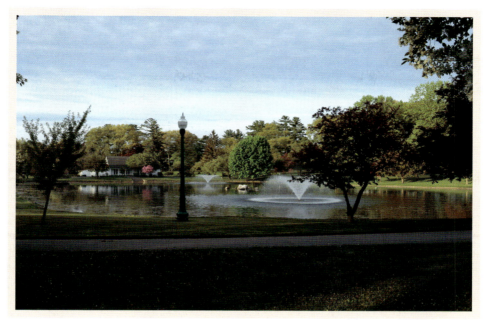

This is a very early image of Hoopes Park. Just a few homes can be seen around the park, and the cars appear to be from the 1920s or 1930s. The gardener with a wheelbarrow can be seen in the left-hand corner. Today, Hoopes Park is still in use for residents to enjoy.

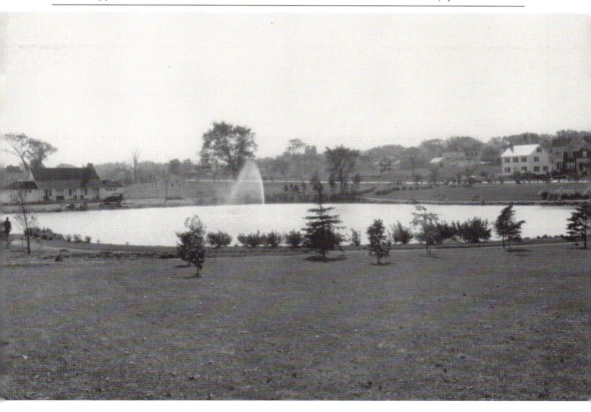

Evolving to Present Day

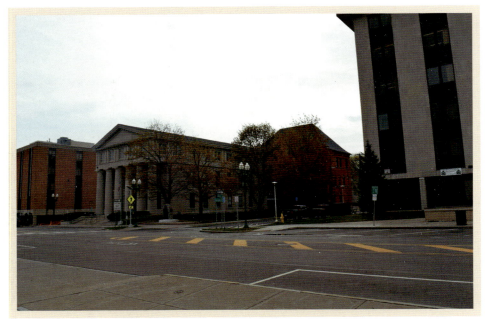

This early-1900s photograph is of the Cayuga County Courthouse on Genesee Street. The Cayuga County Office building stands in place of the home to the right of the courthouse. The Metcalf Plaza stands to the left of the courthouse in place of that home. The Metcalf Plaza was built in 1968. In 1976, the Singer Sewing Center had a storefront in the Metcalf Plaza and sold used sewing machines starting at $29.95.

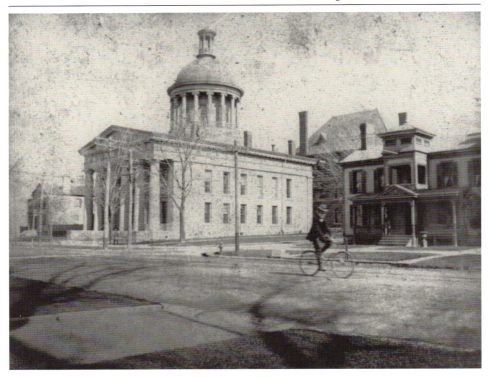

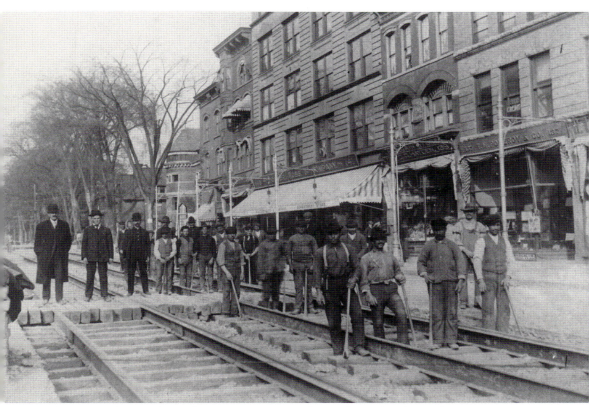

This 1906 photograph is of Genesee Street looking west. The post office can be seen in the far back. Foster and Ross department store can be seen with T.M Pomeroy and Company. The John A. Berger Company is laying the trolley tracks. Today, the Boyle Center sits on the property. Foster and Ross was a leading department store in Auburn in the very early 1900s.

EVOLVING TO PRESENT DAY

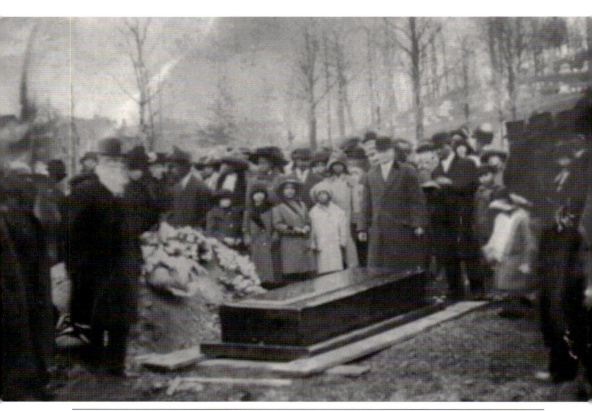

This 1913 photograph depicts the burial of Harriet Tubman at Fort Hill Cemetery. Tubman died on March 10, 1913, of pneumonia. Her funeral was attended by a large group of family and friends. The landscape around the grave has changed but can be easily found in the West Lawn section of the cemetery.

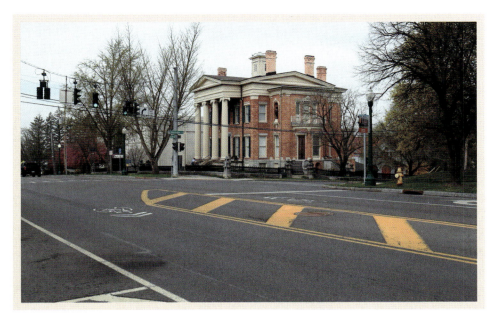

This 1902 photograph of 203 Genesee Street was the home of two prominent families: the Willards and Cases. Dr. Sylvester Willard purchased the Greek Revival mansion in 1843 and lived with his wife, Jane, and daughters Caroline and Georgiana. The Case family inherited the property in 1916, and Theodore Case invented sound film technology in a laboratory behind the mansion shortly after. Today, the building is the home of the Cayuga Museum of History and Art.

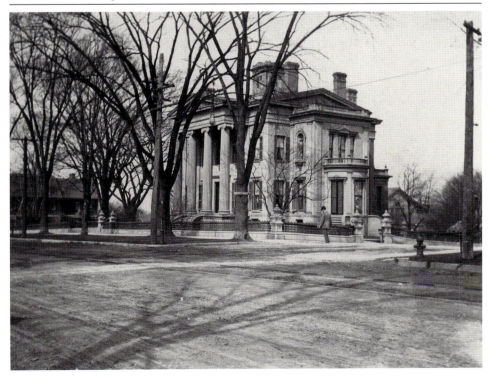

Evolving to Present Day

The New York Central & Hudson River Railroad on State Street can be seen in this 1920s photograph. This view is looking north down State Street, right in front of the prison. The prison gate can be seen just on the left. Today, the prison remains, and a Kwik Fill gas station and auto repair shop are across from it. The Auburn & Syracuse Railroad opened in 1834. The entire rail system served the Great Lakes region. (Past image, courtesy of Peter A. Signor, Smith's Old Country Store Museum.)

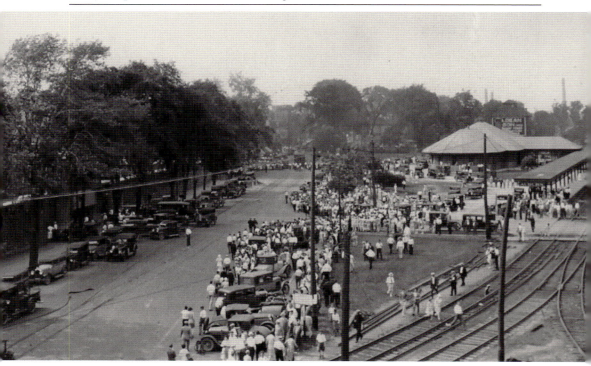

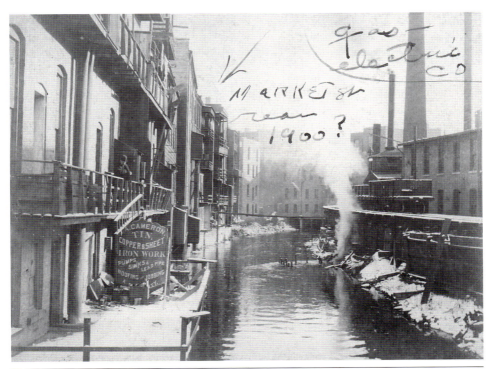

This early-1900s photograph is looking down the outlet from North Street; Market Street is to the left. A. Cameron Tin Copper and Sheet Iron Works sign can be seen on the left. Helmer & Dennis sold workhorses and draft horses at 44 Market Street at the time of this image. Today, all the buildings pictured are gone, making way for a city park, parking, and Loop Road.

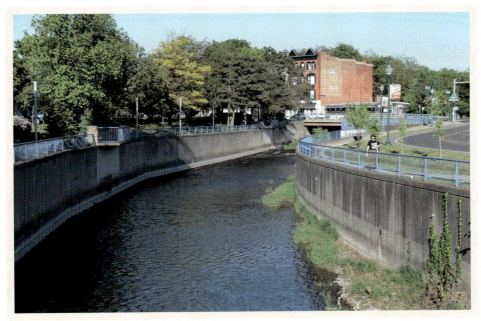

EVOLVING TO PRESENT DAY

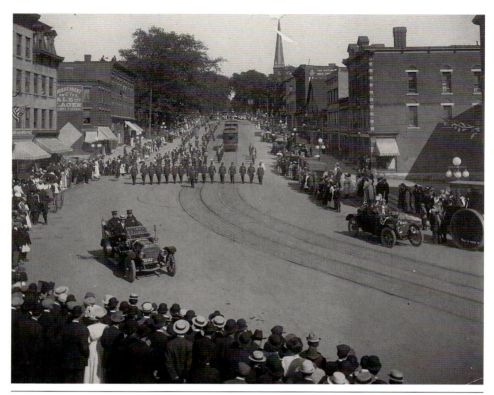

This 1911 photograph is of a parade on the East Genesee Street hill. Spectators line the street and watch as a line of police officers in uniform walk down the hill, followed by a marching band. Two trolley cars sit on the right track, and two open automobiles drive down the hill in front of the marchers. Although some of the buildings have changed, Auburnians still enjoy parades down East Genesee Street to this day.

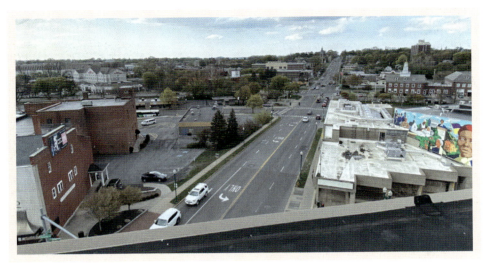

Shown is a 1941 photograph of a parade on North Street near the Genesee Street intersection. Auburn Trust Company is on the right of the intersection, and Whelan Drug Co. is on the left. Crowds of people line the streets. Two buses are parked in front of the trust company. A marching band from Auburn High School leads the parade, and a long line of cars and tanks follow behind them. Garland is strung over streets and wrapped around light poles, and the crowd is dressed in coats and hats. Today, all of these buildings are gone. The present-day photograph was taken on top of the Phoenix Building. (Past image, courtesy Andrew Simkin.)

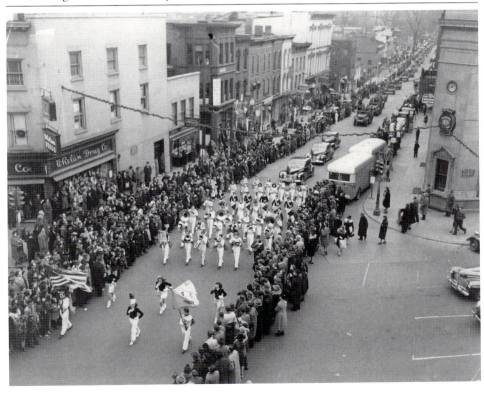

Evolving to Present Day

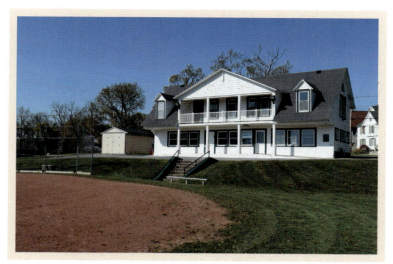

This picture shows two men standing beside a horse pulling a snow scoop. The Clifford Field clubhouse can be seen in the background across a snow-covered lawn. A third person shovels snow near the steps leading up to the front door of the house. In June 1976, the field was dedicated as the Jack Clifford Memorial Field. The field and clubhouse are still in operation today.

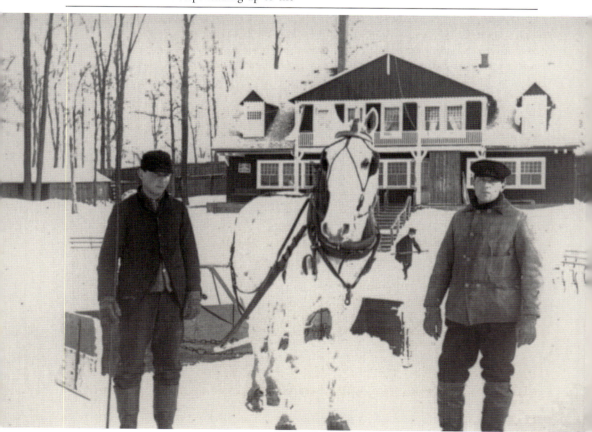

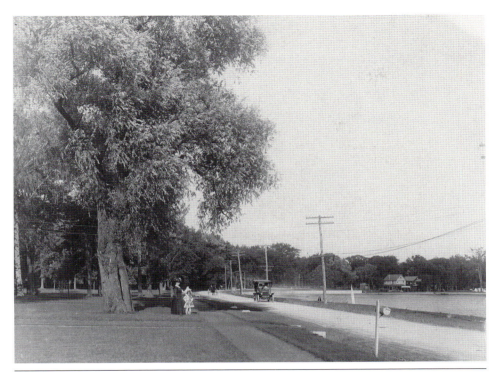

This is an image of Owasco Boulevard at the foot of Owasco Lake in the early 1900s. The road is not yet paved. A horse and buggy can be seen in the far back just behind the car. Notice the tent on the beach. Today's road travels the same path. Gone are the sidewalks shown in the past image.

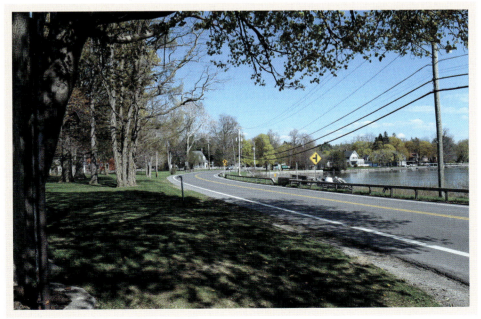

Evolving to Present Day

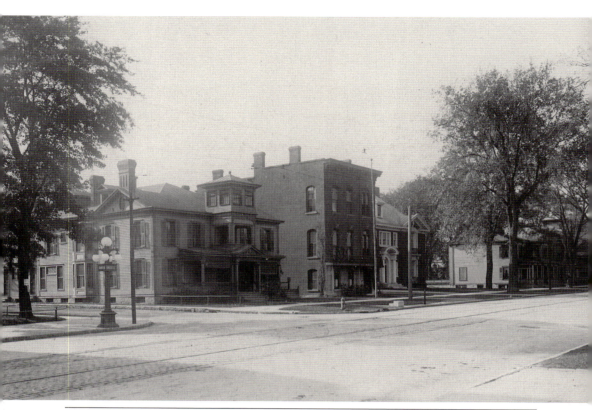

This 1910 photograph was taken at the corner of Genesee and Court Streets, looking across the street toward a row of homes. The house on the corner is a two-story home with a square three-story section on the front with a covered front porch. There is a streetlight with a street sign indicating Court and Genesee Streets on the corner opposite the row of houses. The home was originally Israel Reeve's house, later the home of A. Underwood, and finally Dr. Parker's home before being knocked down. Today, the Cayuga County Office building, erected in 1969, sits on the site.

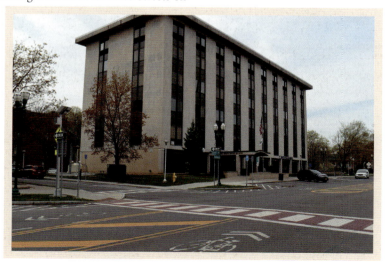

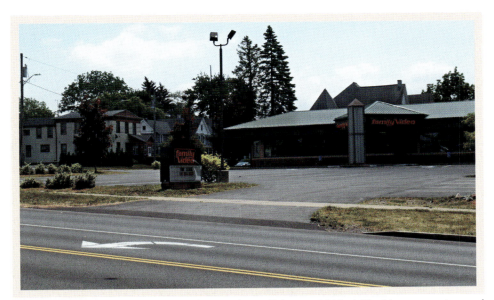

Pets Mobile, on the corner of Fulton and Genesee Street, opened in 1970. Owner Peter Petrosino moved the business to York Street in February 2008. A Blockbuster movie rental store was built in its place; it has since closed. (Past image, courtesy of Peter Petrosino.)

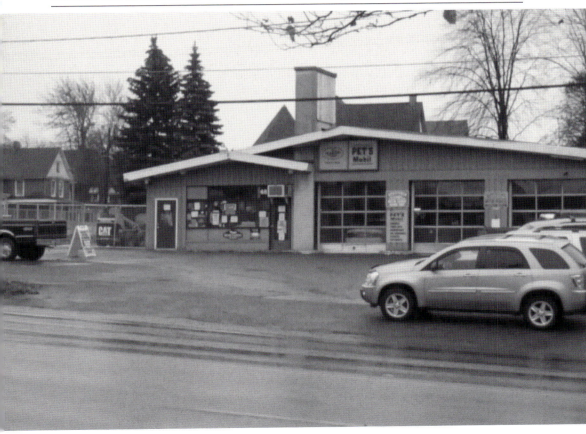

Evolving to Present Day

The 1930s photograph is looking west on Genesee Street from Market Street. Auburn Public Market can be seen just behind the trolley. The Dean Dillingham Coal Company is just to the right of the food market. In 1915, the Auburn Public Market owners, Cooper and Son, ran an advertisement for home cured bacon for 20¢ a pound. At the time, they had several grocery stores in Auburn. All the buildings shown were taken down during urban renewal. Today, the area is a city park.

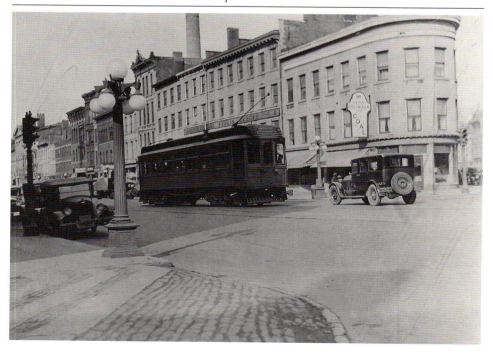

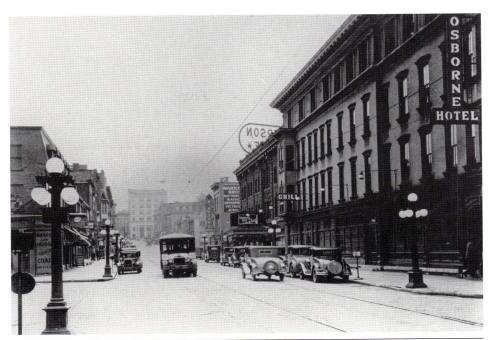

The Osborne Hotel can be seen on the corner of State and Water Streets in 1920. The view is looking down State Street, and the hotel is on the right with the "Osborne Hotel" sign just visible. The four-story brick building stretches down State Street. Signs for *Mother's Boy*, a 1929 musical drama, are visible on the marquee of the Jefferson Theater to the left of the hotel. Markson Furniture is just past the theater. The Jefferson Theater opened in 1908 with 1,600 seats and operated into the 1950s. Empower Credit Union sits in the same location today.

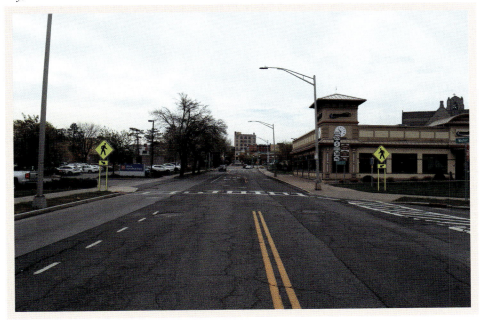

Evolving to Present Day

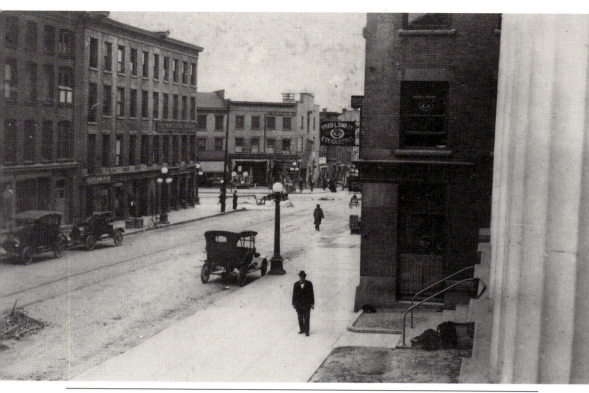

This 1920s photograph is looking north on South Street toward the Genesee Street intersection. The image was taken from the left of the Cady Building. A Fred L. Swart Eyeglasses sign can be seen on the right. Genesee Center, originally the Genesee Mall, was built in 1971 and is across the street now. In 1912, the Auburn Masonic Club moved into the newly remodeled third floor of the Cady Building. George C. Pearson was the chairman of the committee in charge of the move.

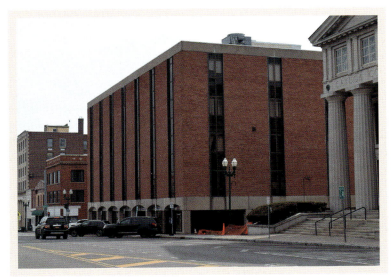

This 1905 photograph is looking across Genesee Street toward the courthouse, which is just visible on the right. Horse-drawn carriages and wagons are parked on the side of the dirt road. Two women can be seen about to cross the street in front of the courthouse behind one of the wagons. There is a small two-story house to the left of the courthouse followed by a row of three-story buildings housing businesses on street level, with one being Wright and Son Dentist. Today, the Metcalf Plaza, built in 1968, occupies the land.

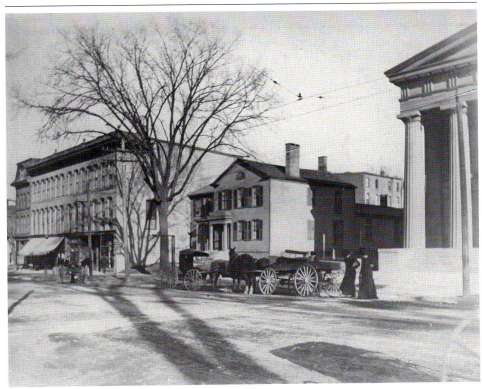

Evolving to Present Day

The photographer was on Genesee Street looking toward South Street in this early-1900 image. Auburn & Syracuse Electric Railroad car No. 52 stops to board people with luggage. A sign for the Rublee company can be seen on the building. The road has not yet been paved. The Auburn & Syracuse Electric Railroad operated between 1908 and 1931. Irving H. Rublee worked at the Rublee Company for over 50 years. His father, Hiram Rublee, started the company, which made tents and awnings.

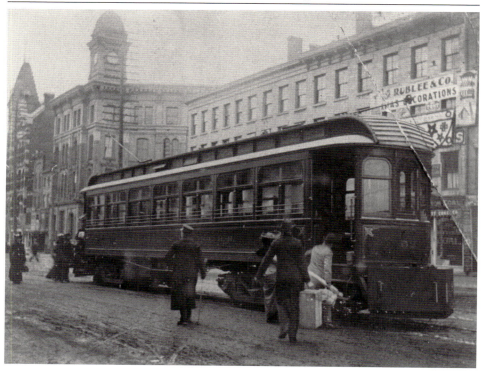

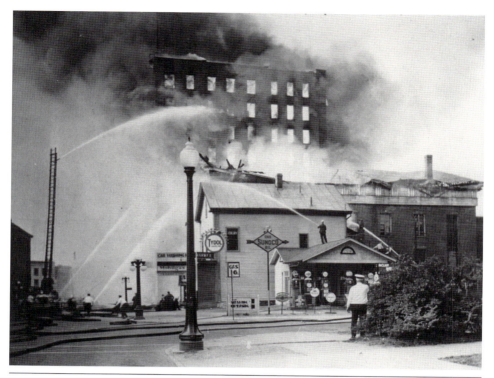

In 1932, the Second Presbyterian Church on South Street burned down. The photograph is on South Street looking north. The building next to the church also burned down. At the time, the second building was Auburn's tallest structure. The fire made way for the Schines Theatre to be built. The Shines Theatre was completed in 1938.

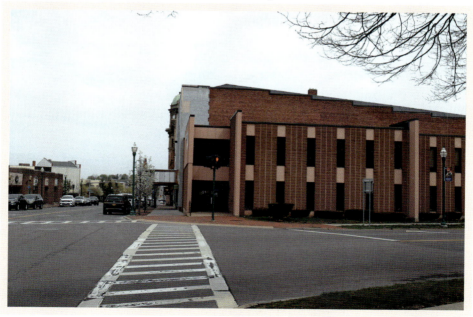

EVOLVING TO PRESENT DAY

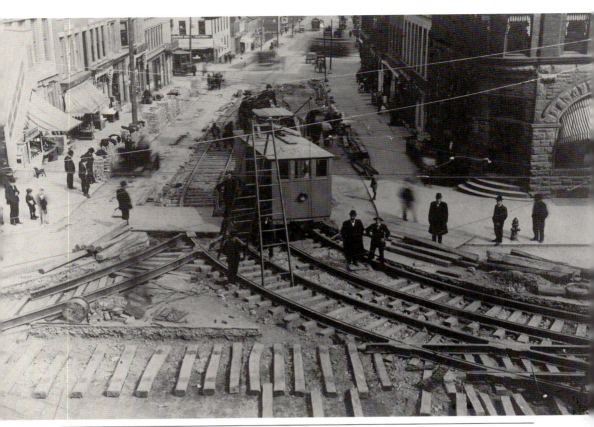

This 1906 photograph taken on Genesee Street is looking down State Street. The John A. Berger Company is laying new trolley tracks in the street. Residential homes can be seen in the distance along with a trolley on what would be today's Loop Road. Most of the buildings on the left are gone today.

Evolving to Present Day

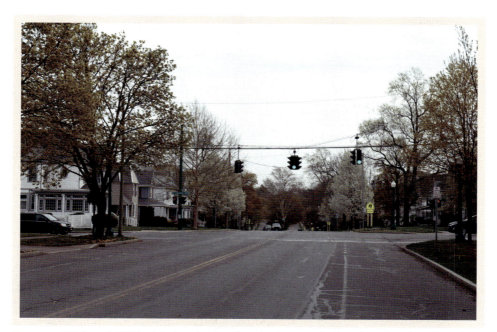

Between 1904 and 1919, this hand-colored photograph of the traffic circle was taken on East Genesee Street at the Seward Avenue intersection. Trees line the street in front of the houses. Red and pink colors have been added to tree trunks and leaves, the traffic circle, flowers, and some roofs. Today, some of the same houses can be seen.

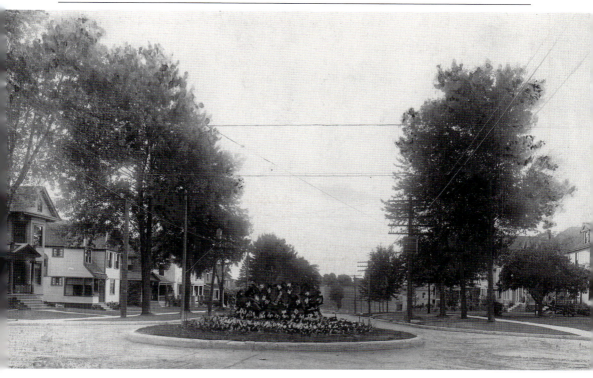

EVOLVING TO PRESENT DAY

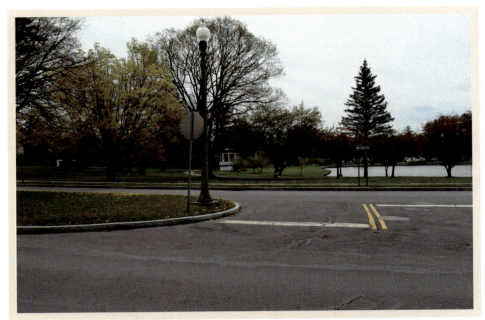

This 1915 photograph shows a car accident on East Genesee Street near Marvine Avenue. A group of men and kids stand on the far side of a brick-paved road with trolley tracks surveying the mangled vehicle. One man on a bicycle is to the left of the group with two unharmed cars behind them. In the background is today's Hoopes Park. Herman Avenue School was behind the photographer.

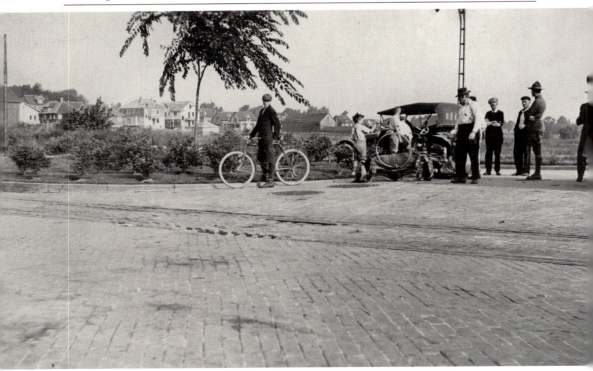

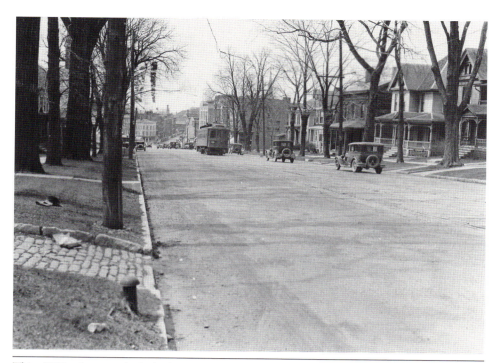

This 1920 photograph is looking west on Genesee Street from East Hill. A commercial district is visible farther down the street. The Flat Iron building can be seen, with Market Street going off to the right. Today, the houses are gone and have been replaced by commercial businesses like Cases Unlimited and Mavis Auto.

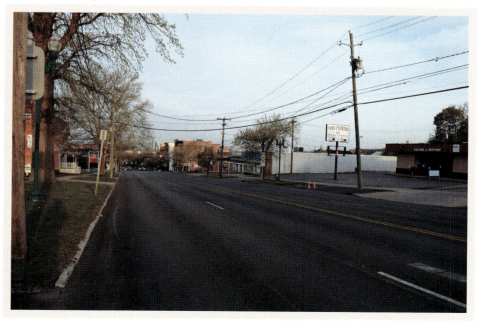

EVOLVING TO PRESENT DAY

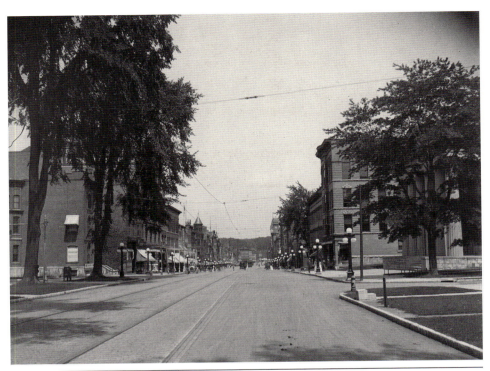

Taken between 1910 and 1915, the photograph above is looking east on Genesee Street. The courthouse is in the right foreground. Trolley tracks are visible down the center of the street. Marshalls clothing store, Hislop's, and Wait's clothing store can be seen going down the left. In 1920, Marshalls ran a newspaper advertisement for "Palm Beach Suits" for men and young men, starting at $12.

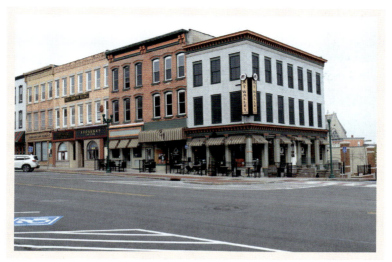

Businesses on Genesee Street decorated with flags and bunting can be seen in the photograph below. The building to the far right, on the corner of Genesee and State Streets, is the Amos T. Walley & Co. Drug Store, with a news and tobacco shop on the left. Outside the news and tobacco shop is a horse-drawn carriage with a sign that reads, "To and From Lehigh Valley Depot." The photograph was probably taken in the early 1900s (between 1900 and 1930). Today, A.T. Walley & Co. has the corner structure, and the Muldrow Building is to the left.

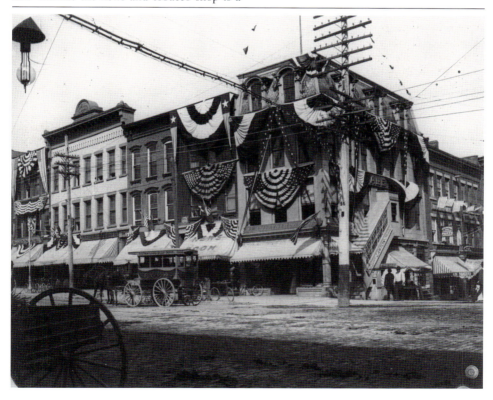

EVOLVING TO PRESENT DAY

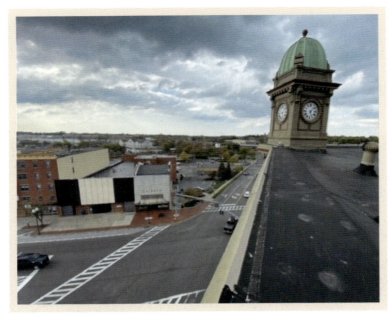

Seen below is an early-1900s image of the North and Genesee Streets intersection. The clock tower belongs to the Auburn Savings Bank on the corner of Genesee and South Streets. The original image would have been taken from the taller building next to the bank. The clock tower in the picture replaced the older tower in 1904 when the fourth floor was added. Today, Andrew Simkin owns the Phoenix Building and has made it his life's work to restore the structure to its original condition.

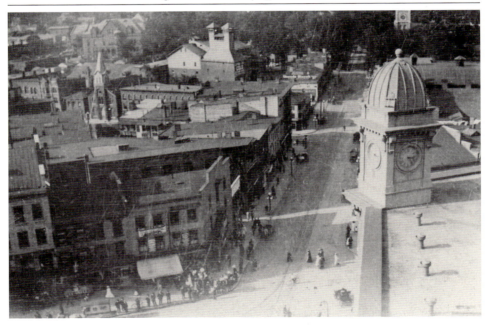

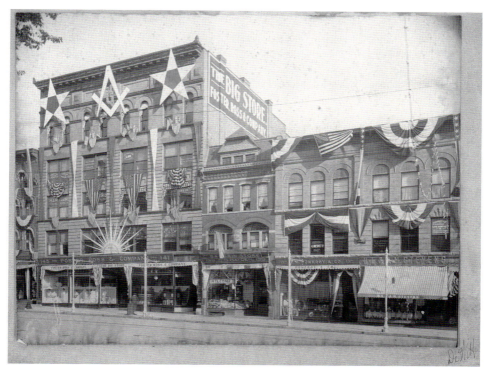

Foster, Ross & Company and the Big Store are pictured in this 1906 image. C.G. Hayden Bargain Store, Pomeroy & Co. (stoves and hardware), and H.L. & A.M. Stevens (clothing store) are to the right of the Big Store. Flags and bunting are in the windows of the Big Store, with the Masonic star and square and compass symbols hung at the top of the building. Today, this area is occupied by the Edward T. Boyle Center Apartments. The Boyle Center was built in 1980 and has 150 residential units.

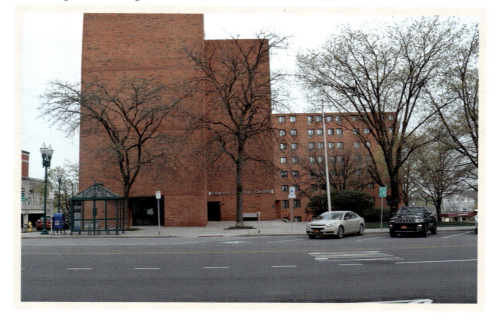

Evolving to Present Day

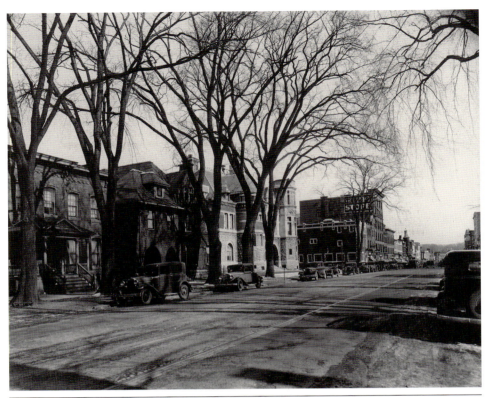

This 1930s photograph shows the old post office in the center with the Elks building on the right. Each side of the post office has changed. The homes on the left have been replaced by commercial buildings. To the right, the Edward T. Boyle Center now stands.

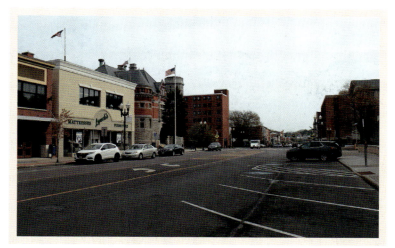

In this image captured between 1904 and 1919 is the West Genesee Street residential area. Houses line both sides of the street with grassy areas in between the sidewalk and street. A trolley can be seen traveling up the left side of the road. The business section is visible in the distance. The courthouse dome is visible on the right. Today, Lynch's Furniture can be seen next to the post office. Lynch's Furniture was founded by Daniel Lynch in 1905 and is still family-owned.

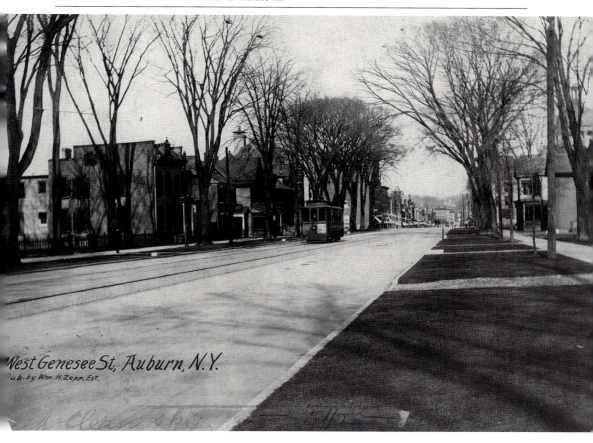

EVOLVING TO PRESENT DAY

The photograph below of L.E. Andrew's store and Dean-Dillingham Coal store on the "Swaby Block" of South Street was taken between 1906 and 1911. Two men and three kids stand in front of the shop. Just to the left would be today's Phoenix Building. Swaby's Tavern operates today out of a newer building. On December 23, 1926, Dean-Dillingham advertised "Good Clean Coal" along with a Christmas card accompanying Friday's delivery.

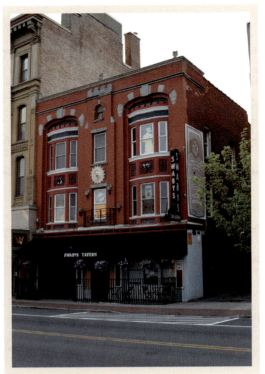

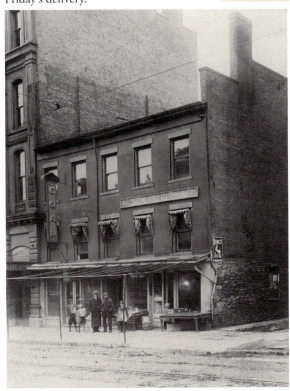

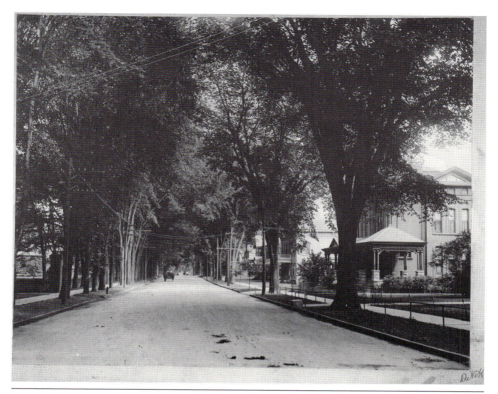

This view looking north on South Street approximately from the Hamilton Avenue intersection was captured between 1880 and 1910. The tree-lined residential street with a horse-drawn wagon coming up the road toward the viewer can be seen. Some of these same houses can still be seen on South Street today.

Evolving to Present Day

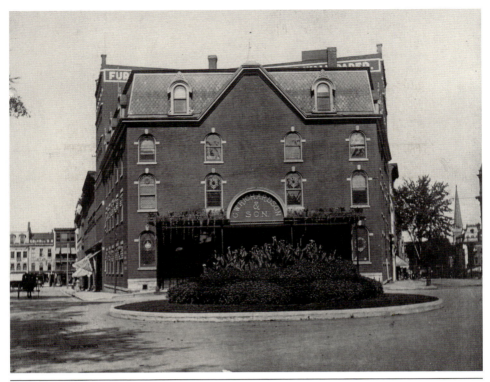

In this 1904 photograph, G.W. Richardson & Son furniture store at the junction of South and Exchange Streets can be seen. Taken from the front of the building looking north, the image shows the four-story brick structure in front with a six-story back half. Horse-drawn carriages can be seen going down Exchange Street to the left. The Silbert Optical Building is at the end of Exchange Street. In 1906, G.W. Richardson & Son celebrated 92 years on the "South Street Triangle."

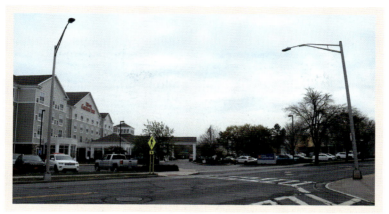

The photograph below of businesses on Water Street was taken between 1954 and 1957. Rondina Furniture Store (at the corner of State and Water Streets), GE Appliances, and Ramsey Motors (35 Water Street) occupy the three-story brick building. In March 1954, the display windows in Rondina Furniture Store were blown out by a gas explosion. Ramsey Motors has a sign for "Approved Packard Service" and "Studebaker." Herbert Bros. Warehouse is visible in the building on the far right. Today, the building and street are gone, making way for the Hilton Garden Inn.

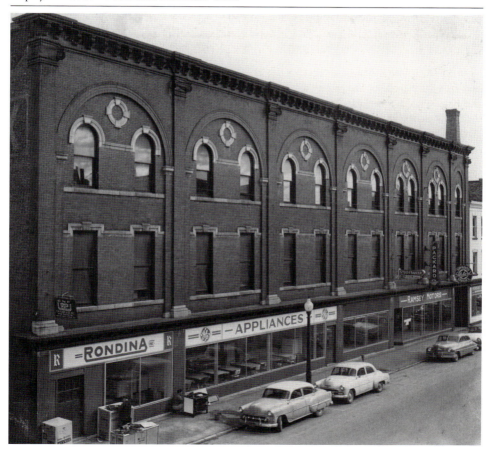

Evolving to Present Day 63

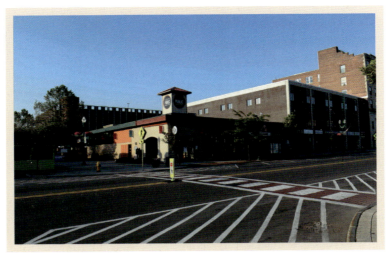

The image below is of the Smith & Pearson Hardware store on the corner of Genesee and Exchange Streets in 1953. Union Clothing Store and Endicott Shoes are to the right of Smith & Pearson. A real estate office can be seen on the second floor above Smith & Pearson. In 1935, Smith & Pearson advertised "The New Westinghouse Electric Refrigerator" for the "Streamline Age." Auburn Public Theater, seen in today's photograph, got its start in 2005 when Carey Eidel and Angela Daddabbo purchased the property and opened the theater.

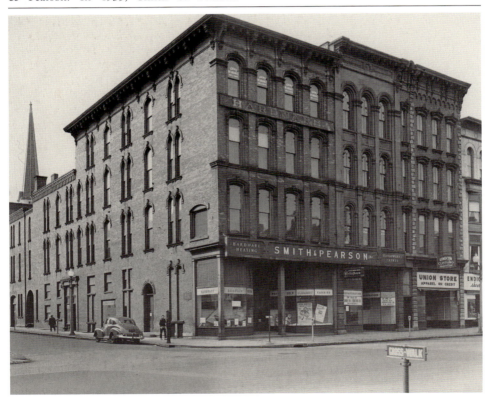

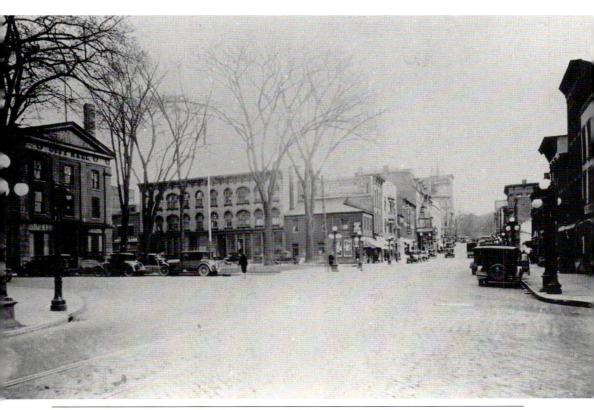

This 1930s image of North Street is looking south. The old city hall is the first building on the left. This would be today's Police Department Building. The old city hall was erected in 1836 and torn down in 1931. With the exception of the Phoenix Building at the very top of the photograph, all of these structures have been taken down.

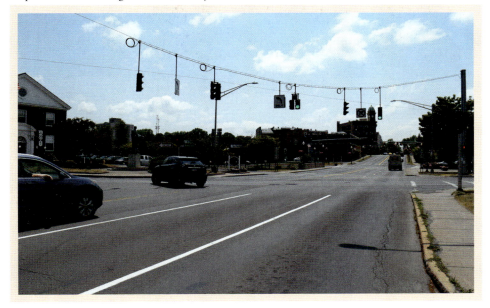

Evolving to Present Day

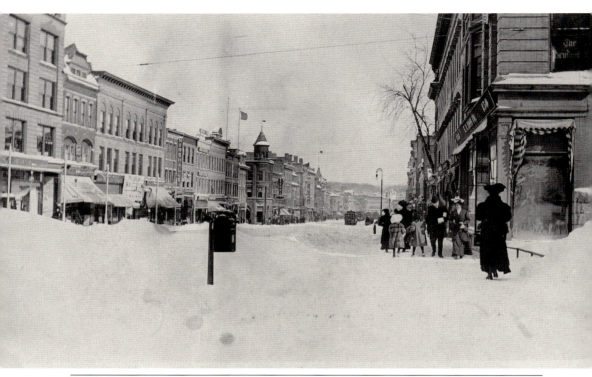

Snow blankets Genesee Street after a snowstorm in this early-1900s image. High snowbanks line the street, with pedestrians on sidewalks, and trolleys are in the distance. Signs for Marshalls, Sagar Drugs, Hislop's, and Waits are on the left. E.N. Ross is to the right. In 1961, Hislop's ran an "Epic Eightieth Anniversary" sale. The new fall handbags went for $2.39, and Revereware tea kettles went for $2.99.

Evolving to Present Day

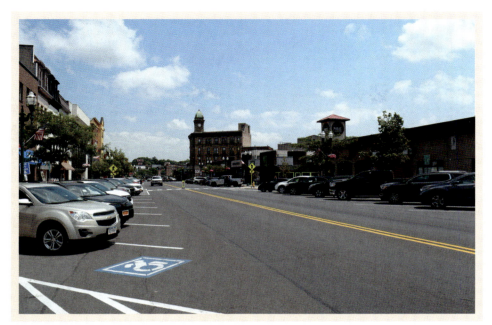

The image below shows Genesee Street after a 1925 snowstorm. Taken from above street level, the Weld & Co. Drugs sign in the left foreground can be seen. Signs for Hislop's and Wait's are visible in the distance on the left. A sign for Empire Gas and Electric can be seen on the middle-right building. The entrance to Exchange Street is between the two buildings on the right. Today, Genesee Center and the Auburn Public Theater occupy this section of Genesee Street.

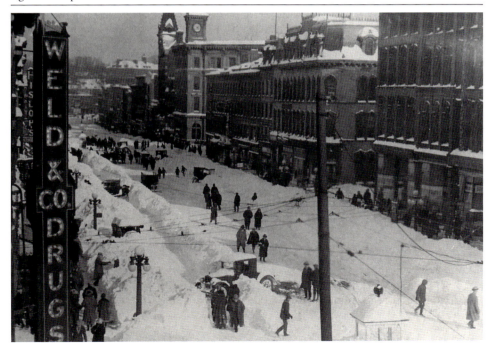

Evolving to Present Day 67

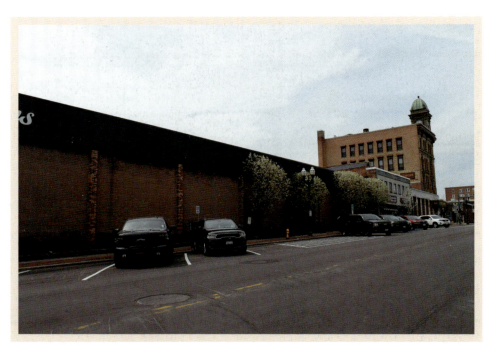

This 1970 image of Genesee Street was taken looking toward the North Street intersection. Signs for businesses, including Traub's, Warden's Paints, Hertz car rental, Fair Deal Furniture Co., and the Palace Theater, can be seen. In 1918, the theater held a fundraiser for the Liberty Fund, naming it "Help Uncle Sam Club the Kaiser, Buy Liberty Bonds." Traub's opened in 1867, and it eventually moved to Grant Avenue.

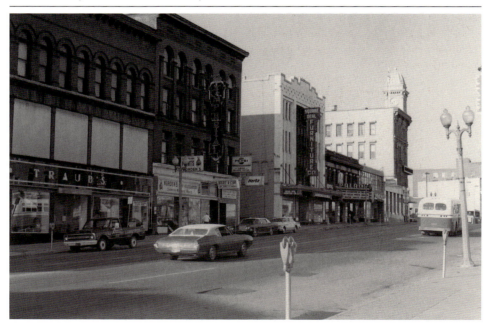

68 Evolving to Present Day

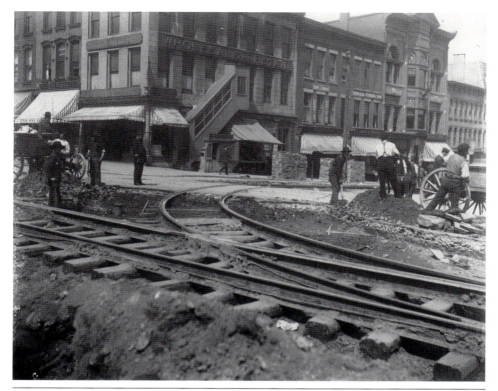

This photograph taken between 1910 and 1920 shows the corner of Genesee and State Streets. Men are digging up the dirt road and placing trolley tracks. Horse-drawn wagons with a group of men can be seen with a policeman standing in road next to group of men on left. Buildings include Zepp's cigar and newsstand at far left. Next to Zepp's is a Walley's drugstore on the corner and a small snack stand, and signs for Dr. W.J. Emens, Dentist–Optician; Murphy Bros.; Max Stenzel, Tailor; and John C. O'Brien can be seen.

EVOLVING TO PRESENT DAY

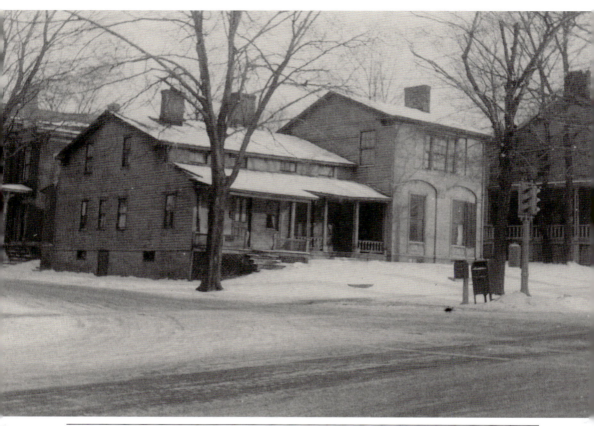

Dirk Lansing, a professor at the Auburn Theological Seminary, lived in this house in 1948. The house was located on the northeast corner of John and East Genesee Streets. Today, Mavis Discount Tire occupies the land.

EVOLVING TO PRESENT DAY

CHAPTER 3

URBAN RENEWAL

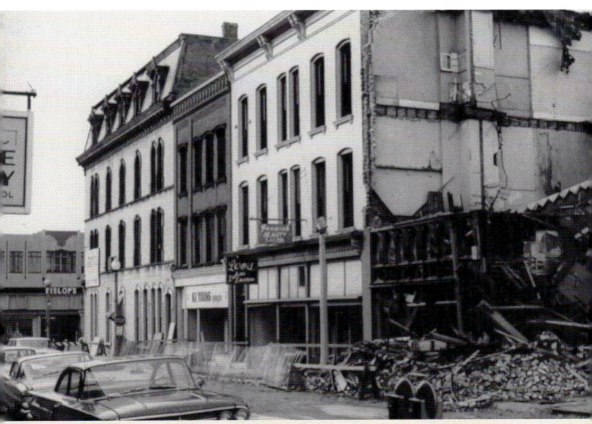

Pictured are buildings on Exchange Street coming down in the early 1970s. Hislop's Department Store on Genesee Street can be seen in the background along with Leo's Ladies Shoppe and Fenwick Beauty Salon.

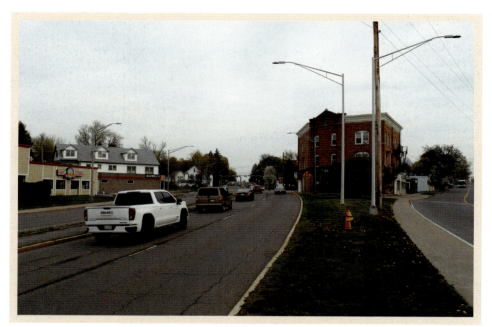

The 1913 photograph is of the Five Points Junction of Franklin Street at Lewis Street. Two trolleys and a horse and buggy can be seen. To the left is Lewis' Drugstore at 44 Lewis Street. In 1953, Lewis' Drugstore offered Lovell & Covel's Candy Cupboard Chocolates for $1.24 a pound. Notice the horse drinking water from a fountain in the center of the image. Today, the arterial splits Lewis Street into two sections of road, divided by a medium. Marks Pizza operates in the general area of the old drugstore.

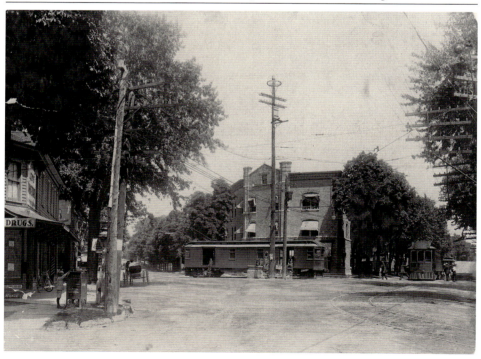

Urban Renewal

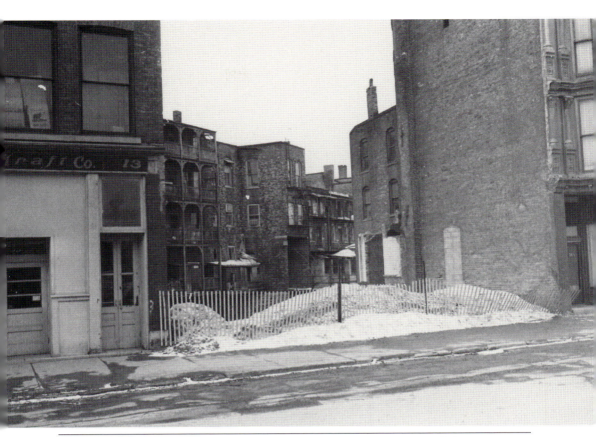

This early-1970s photograph is on Market Street facing the south side of Market Street looking between two buildings. The back of the buildings shown are on Genesee Street. The building on the left has a sign that says Julius Kraft Co. Julius Kraft opened in 1868. This would be in the area of Eliminator Auto. All the buildings in the photograph are gone and have been replaced by a city park. The demolition happened during urban renewal in the 1970s.

URBAN RENEWAL 73

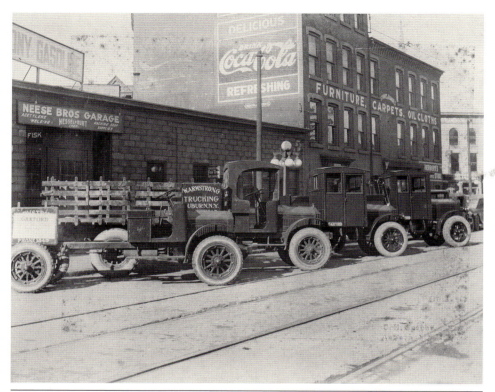

Neese Bros. Garage was located at 7–9 Dill Street. The shop was established in 1902 and had an office at 5 Dill Street. Signs on the building advertise auto parts, welding, and a machine shop, with "Neese Bros Garage Nessel & Burt Shop" painted above the doorway. Several trucks are parked on the street in front with signs for "Garford" and "W. Armstrong Trucking Auburn NY." Herbert's Furniture store is to the right of the garage. The furniture store would have been on the corner of Dill and Water Streets. John F. Stoner sold Oldsmobiles in 1922 just to the left of Neese Bros. Garage at 23 Dill Street. In 1922, Stoner advertised a Super-Sport Roadster for $1,625.

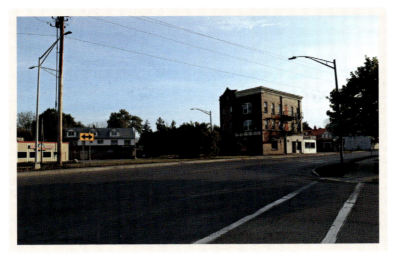

This 1970s photograph is of North Lewis Street at Franklin Street. Today, the section of the road in front of the building is gone, as is the Texaco gas station toward the back of the picture. This made way for today's arterial, splitting up Lewis Street. In the 1930s, Market Basket Food Market, owned by H.E. Hovey and associates, operated in the brick building. They had several markets in Central New York.

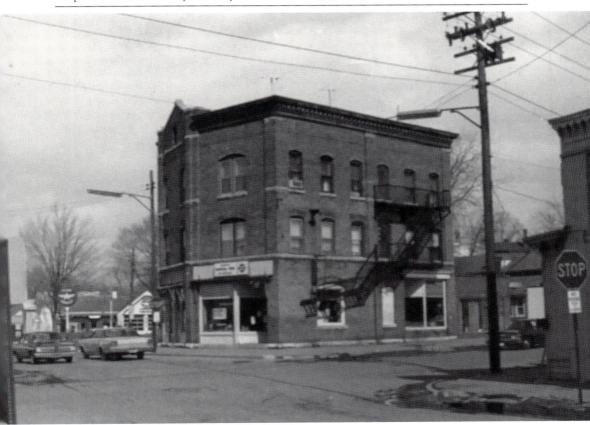

URBAN RENEWAL

Market Street, in a view looking toward North Street, is seen in the 1970s photograph. The Thomas Mott Osborne statue is on the right. The statue is still there today, just in front of the police department. Conaty Fish & Oysters, Gregory & Picciano Electric Co. Inc., Bishop's, a grocery store, and Perfection Dry Cleaners can be seen across the street. A Ford Pinto police car can be seen on the street. Thomas F. Conaty owned Conaty Fish & Oysters. All the buildings shown were taken down during urban renewal.

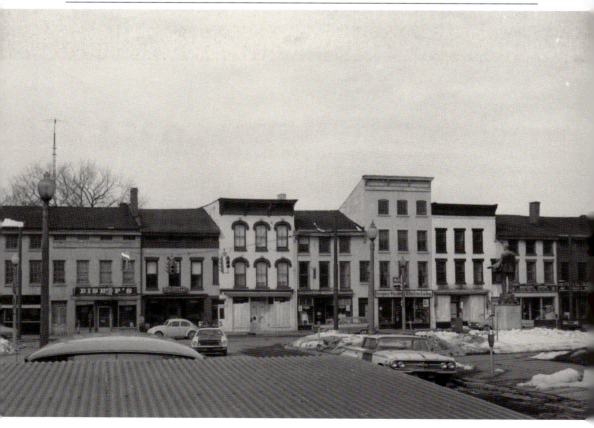

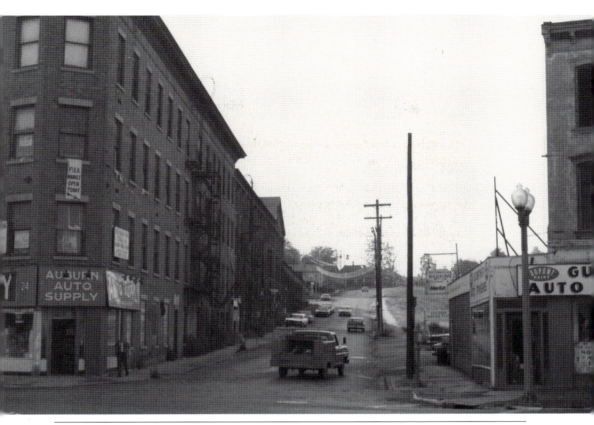

The 1970 photograph is looking south up Osborne Street from today's Loop Road. The four-story brick building on the left houses the Auburn Auto Supply Co. On the right corner is Guenther Auto Finishes. Behind Guenther is a grassy area and a sign for Midtown Plaza Parking with Hertz Car rentals. A sign in Guenther's reads, "We must move, our new location, Nov 1, 7 Franklin Street" This was taken right before the construction of Loop Road in this area, which necessitated the demolition of these buildings, in the early 1970s.

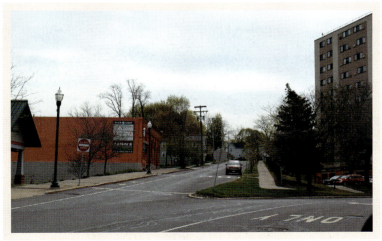

URBAN RENEWAL

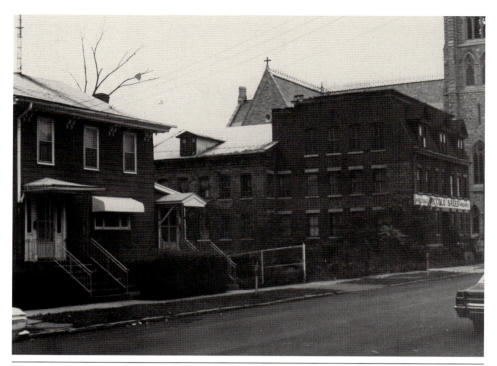

In this view of Clark Street facing Green Street in 1971, a brown-sided house with a white awning over the front window can be seen on the left. A brick building can be seen just to the right of the house. In the far back is St. Mary's Church. The brick building is Piccolos Sales. In 1915, Dr. Francis Welch and William Allyn opened Welch Allyn on the second floor of the brick building. The business expanded and moved over the years. In 2015, Welch Allyn sold for $2.05 billion in cash. Today, the land is used for parking by St. Mary's Church.

URBAN RENEWAL

In this 1980s photograph are Genesee Street, Montones TV and Radio Service, Angelo's Pizza, and a for sale sign for the National Hotel. Mary Todd Lincoln stayed overnight in the National Hotel. Today, the property is used as a parking lot.

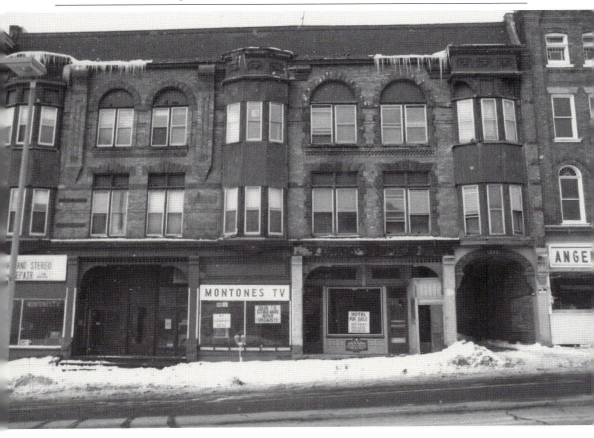

URBAN RENEWAL

The photograph below of Genesee Street is looking across the road toward Hunter Dinerant. Auburn Auto Supply store is on the corner to the right of Hunter. A sign for Fay's Drugs is painted on the brick building to the left of Hunter. This was the late 1960s or early 1970s before urban renewal construction began. Today, the land on the corner is a city park. The Fay's Drugs sign can still be seen.

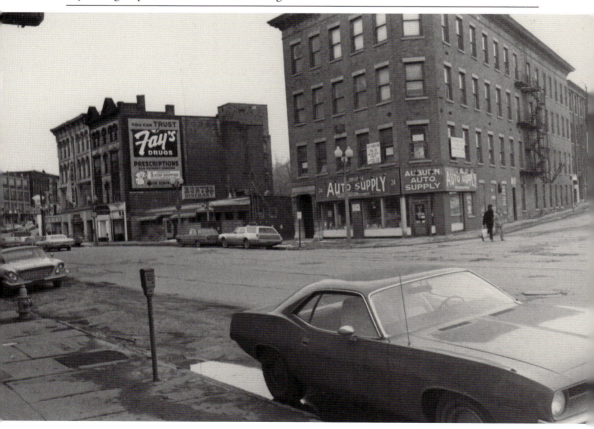

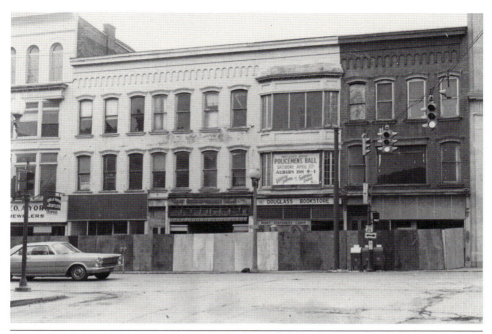

This is a photograph of Genesee Street where the Genesee 110 building stands today. Signs for the Geo A. York Jewelry store and Douglass Bookstore are on the buildings. Above Douglass Bookstore is a sign for the "Thirty Eighth Annual Policemen's Ball Saturday, April 22nd, Auburn Inn–9 to 1, Harry James and the Swingin' Band." In 1961, the Douglass Bookstore ran an advertisement in the newspaper thanking patrons for their 21st year in business. In 1984, George A. York was recognized by the American Gem Society with an accredited gem certificate.

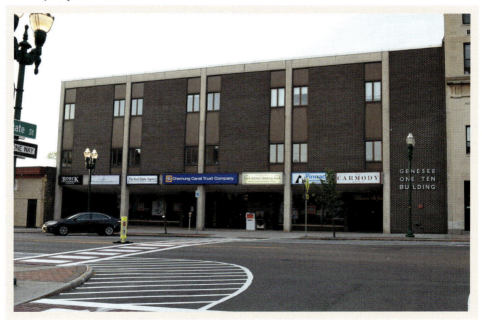

URBAN RENEWAL

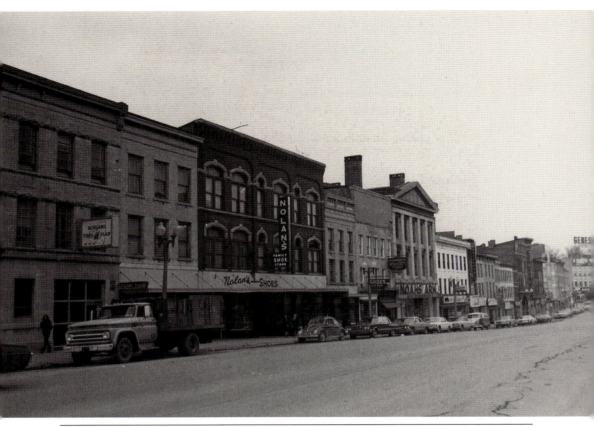

Looking down Genesee Street from the North Street intersection, this 1970s photograph shows the Midland Time Plan sign on the leftmost building. Nolan's Shoes, Poolos Candy, and Noahs Ark are to the right, with the Genesee Beer sign visible at the bottom of the street. Today, only a few of the buildings remain, as most were taken down during urban renewal. George C. Poolos operated Poolos Candy for over 25 years. George's nephew Gus Poolos took over when George retired.

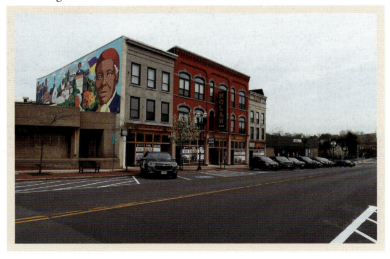

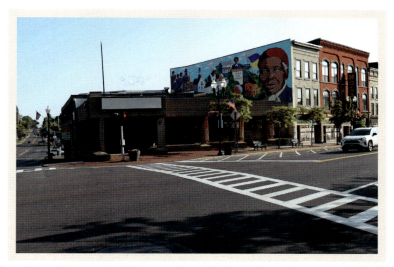

The Auburn Trust Company building on the corner of North and Genesee Streets can be seen in the photograph below. Cars are on the street, and a bus is visible around the corner on North Street. The bank has a sign for Marine Midland Trust Company. Nolan's Shoes is visible on the right; farther down Genesee Street, a G.W. Hornbeck Plumbing and Heating van sits in front of the bank. G.W. Hornbeck was located on Seminary Avenue.

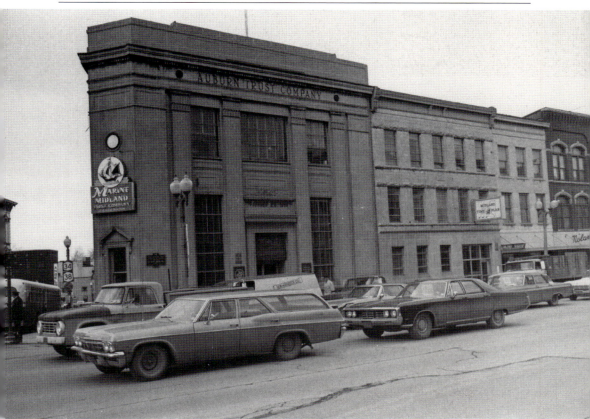

Urban Renewal

The building in the left foreground is on the corner of North and Genesee Streets and has a sign in the window that says, "Cosman's has moved back to South and Genesee." The Hub Shoe Rebuilding sign is on the fifth building down, next to Joey's and Seal's Camera Store. In 1930, Hub Shoe Rebuilding, then located at 13 Exchange Street and owned by Ross Cosentino, won a state award for outstanding service. This was taken right before urban renewal in the 1970s. Angelo's Pizza can be seen in the distance in what would be right across from the police department.

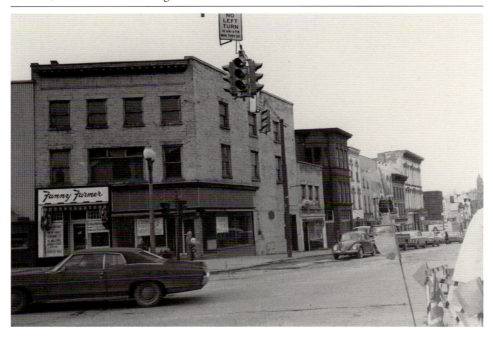

84 URBAN RENEWAL

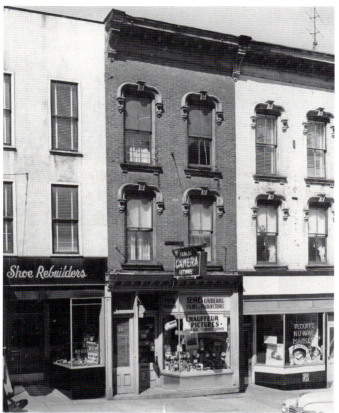

Seal's Camera Store was located at 11 North Street in this 1959 photograph. Hub Shoe Rebuilding is to the left with Plouffe NuWay Market to the right of Seal's. All are three-story buildings with street-level display windows. All are now gone, making way for a wider North Street. In 1960, Seal's Camera Store had a sale of eight-millimeter movie cameras. A Bell and Howell Turret camera with a meter was on sale for $72.

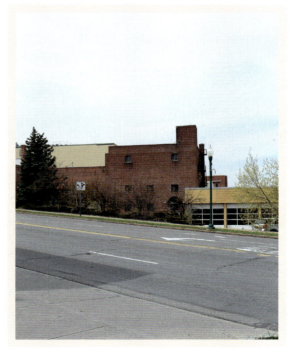

URBAN RENEWAL

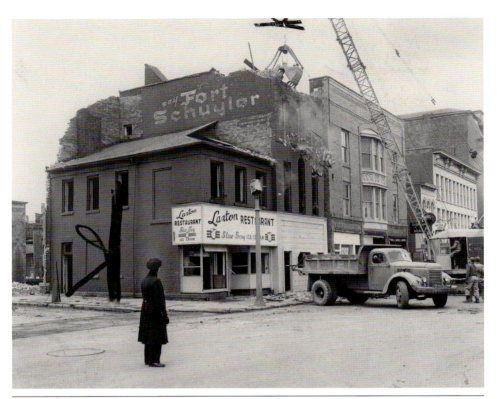

The image above is of the Laxton Restaurant building being demolished, making way for urban renewal in the 1970s. The building was on the corner of Market and North Streets. Next to the restaurant is a liquor and wine store along with Brooks News. Today, the land is used as a parking lot for the police department along with a small park. William Lawton, originally from Huntingdonshire, England, ran the restaurant with his son Frederick Laxton.

This 1970s photograph of North Street is looking toward Genesee Street. Water Street is to the left, and the row of buildings to the right has signs for the following businesses: Hub Shoe Rebuilding, Kodak, Biltmore Restaurant, Seal's Camera Store, and the Savings and Loan Association. Today, the buildings on the right are gone, making way for urban renewal.

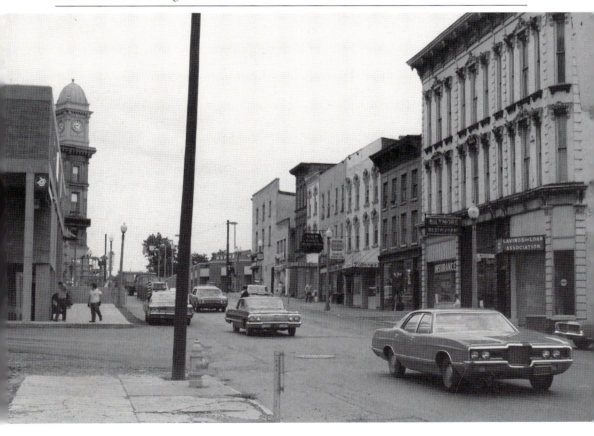

URBAN RENEWAL 87

North Street from the intersection at Genesee Street can be seen in this 1970 photograph. On the left side of the street are a sub shop, Hub Shoe Rebuilding, a bakery, Seal's Camera Store, Biltmore Restaurant, and Angelo's Pizza. Angelo's Pizza was originally located on Genesee Street at South Street. It moved to North Street near Tubman Park at the time of this photograph and later moved to its current location on East Hill in 1973. Angelo D'Angelo opened the business in 1960, later selling it to Matt Bartolotta.

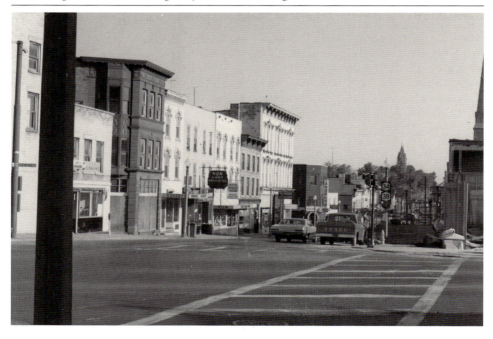

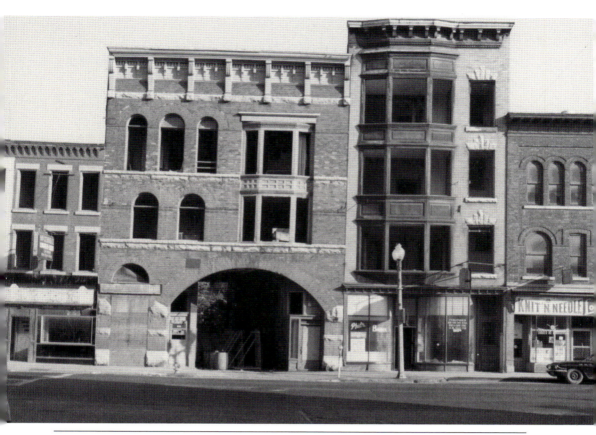

This image of the buildings along Genesee Street between Market and South Streets was taken in the 1970s. The structures are empty. Urban renewal and the construction of the arterial in the early 1970s resulted in many buildings being demolished. The sign on the far right is for Longo's Knit'N Needle. The building with the arch is on today's Loop Road. Longo's Knit'N Needle held a grand opening on July 16, 1964, advertising exclusive Columbia Minerva yarns.

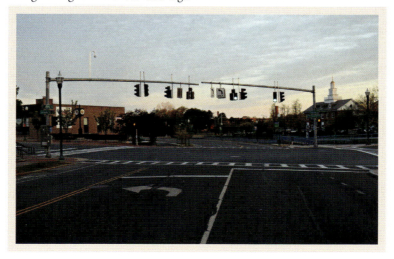

URBAN RENEWAL

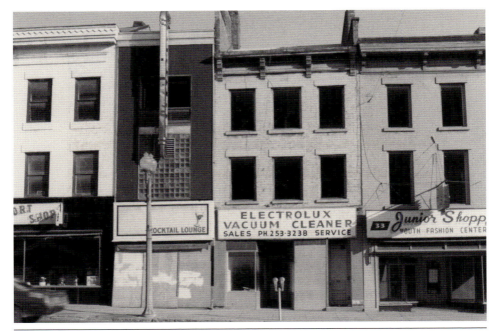

This 1970s photograph shows shops along Genesee Street near today's Loop Road. Bob Nolan Sport Shop is at far left, and a cocktail lounge, Electrolux vacuum cleaner shop, and Junior Shoppe youth fashion center can be seen to the right. Clarence Nolan opened Nolan Shoes, and Bob Nolan eventually branched off and opened the sport shop all in the same block. The Nolan family business operated for 68 years.

This 1960s image was captured on Genesee Street between Loop Road and North Street. Thomas Shoes, Poolos Candy, Noahs Ark auto accessories, and Bob Nolan Sport Shop can be seen in the image. Noahs Ark occupies the spot where the old Cayuga County National Bank stood. The bank was erected in 1834, and the building was demolished in the 1970s. In 1976, Bob Nolan Sport Shop ran a sale on a 15-foot aluminum canoe for $310, which included two free paddles.

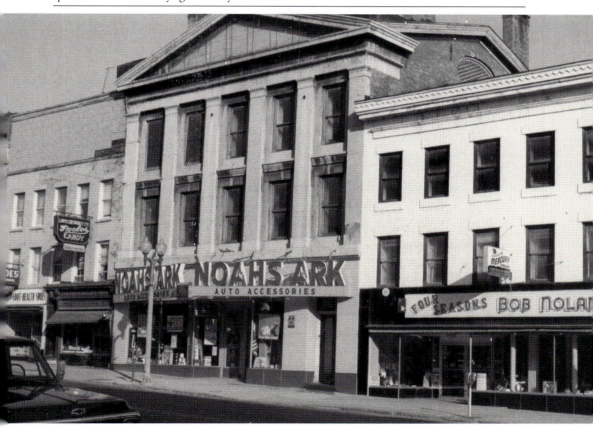

URBAN RENEWAL

The 1930s photograph was taken on Genesee Street in front of the county courthouse, looking east. The Big Store can be seen on the left. On the right next to the courthouse is a supermarket. Today, a mosaic on the side of the Boyle Center depicts the former Big Store, one of Auburn's largest department stores. In 1924, the store had a sale on hand-painted gingham dresses for $2.29.

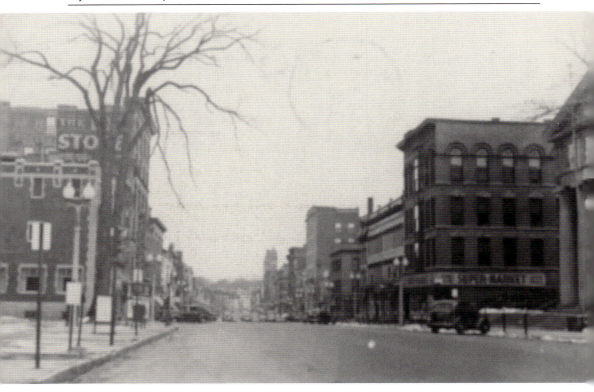

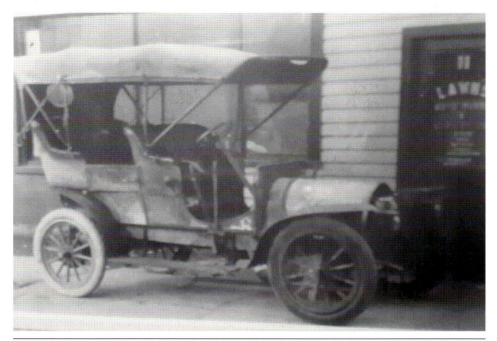

The early-1900s picture is of the Michael J. Lawn Tow Company. Between 1934 and 1942, Lawn bought wrecked cars and removed the good parts to sell. Lawn had three tow trucks on the road during this time. Today, its location is in what would now be the Loop Road entrance to Wegmans. Michael Lawn's son Mark Lawn owns Mark J. Lawn Optical today. (Past image, courtesy of Mark Lawn.)

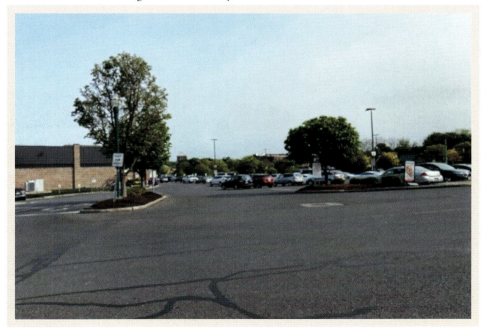

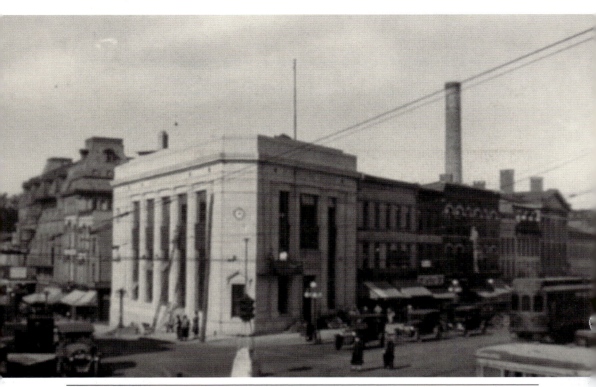

The corner of North and Genesee Streets is pictured with the Auburn Trust Company on the corner around 1920. Notice the traffic signal in the middle of the road sitting on the street. The Capitol Theater can be seen just behind the bank on North Street. Today's building was erected in 1972 for Marine Midland Bank.

This early-1900s photograph was taken on North Street looking south toward Genesee Street. Behind the clock tower is Auburn's largest building at the time. The building burned to the ground in 1932.

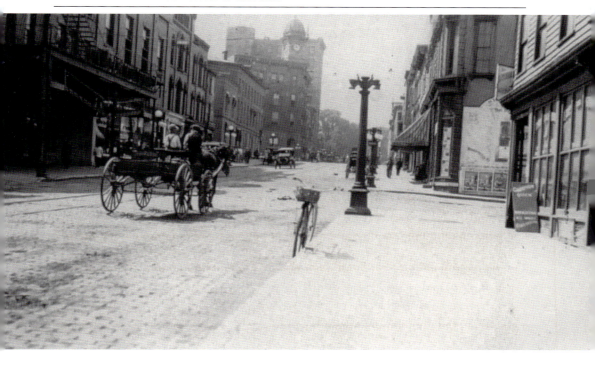

Urban Renewal

Discover Thousands of Local History Books
Featuring Millions of Vintage Images

Arcadia Publishing, the leading local history publisher in the United States, is committed to making history accessible and meaningful through publishing books that celebrate and preserve the heritage of America's people and places.

Find more books like this at
www.arcadiapublishing.com

Search for your hometown history, your old stomping grounds, and even your favorite sports team.

Consistent with our mission to preserve history on a local level, this book was printed in South Carolina on American-made paper and manufactured entirely in the United States. Products carrying the accredited Forest Stewardship Council (FSC) label are printed on 100 percent FSC-certified paper.